Fearless Genius:
The Digital Revolution
in Silicon Valley,
1985–2000

$5mV/10$ $500\mu V.$ $5\times10^{-4}/25.$
$2\times10^{-5}/nm$
$2\times10^{-6}/\text{Å}$

$1mV/10$ $100\mu V$ $1\times10^{-4}/25$
$2\times10^{-6}/nm$
$2mV/10,$ $2\times10^{-7}/\text{Å}$
$2.\times10$

3×10^{-5}

$7.5mV/10$

$10N/$

$\times12$

$1\times$

V_{out}

$.5 \quad .25$

300

$0.1 \quad mV$

Fearless Genius
The Digital Revolution in Silicon Valley, 1985–2000

Doug Menuez

Foreword by Elliott Erwitt

Introduction by Kurt Andersen

ATRIA BOOKS

NEW YORK LONDON TORONTO SYDNEY NEW DELHI

ATRIA BOOKS

A Division of Simon & Schuster, Inc.
1230 Avenue of the Americas
New York, NY 10020

First Atria Books hardcover edition May 2014

ATRIA BOOKS and colophon are trademarks of Simon & Schuster, Inc.

For information about special discounts for bulk purchases, please contact Simon & Schuster Special Sales at 1-866-506-1949 or business@simonandschuster.com.

The Simon & Schuster Speakers Bureau can bring authors to your live event. For more information or to book an event, contact the Simon & Schuster Speakers Bureau at 1-866-248-3049 or visit our website at www.simonspeakers.com.

Designer: Julian Peploe
Picture Editor: Karen Mullarkey
Editorial Assistance and Text Editor: Joanna Lehan
Research: Kathy Dolle Molly
Editorial and Studio Assistant: Molly Peters
Jacket design by Anna Dorfman
Jacket photographs by Doug Menuez

Manufactured in China

10 9 8 7 6 5 4 3 2 1

ISBN 978-1-4767-5269-3
ISBN 978-1-4767-5273-0 (ebook)

The photographs in this book and 250,000 others from this project are now archived at Stanford University Library, where they are being researched, catalogued, and preserved for public access. If readers have additional information on the specific content of any of these photographs, please write to the author at info@menuez.com.

Previous Spread

The Mathematical Equations of a Nobel Prize Winner.

Zurich, Switzerland, 1997.

Dr. Gerd Binnig (*foreground*), a 1986 Nobel laureate in Physics, has scribbled notations on a whiteboard describing aspects of his nanotechnology research at IBM's Micro and Nanomechanics Group laboratory. Binnig won the Nobel Prize for Physics with the late Heinrich Rohrer for their invention of the scanning tunneling microscope (STM), a device often described as one of the most significant accomplishments in the history of science. They are considered the fathers of nanotechnology, a field that has given rise to such innovations as highly targeted cancer drugs; AIDS-resistant condoms; 3-D printers that can output toys—or human skin; artificial muscles; and self-healing plastic. Despite these seemingly beneficial developments, many have warned of potential threats to humanity raised by this powerful new technology that allows scientists to measure and manipulate atoms.

Para Tereza e Paolo, meu amor sempre.

And for those formerly awkward geeks
who now stride like giants
through a technology wonderland
of their own creation.
Behold the new cool kids!

Contents

Foreword
by Elliott Erwitt

Photographing the unphotographable has long been the passion and the mission of Doug Menuez. How does one photograph genius? How does one visually communicate the creation and dynamics of world-altering concepts and somehow give insights into the personality of the men and women responsible, the people who essentially just sit and think and in so doing profoundly change our lives?

The answer is, call on Doug Menuez.

Photographs of business meetings and of disheveled people sitting and thinking for hours is hardly sexy visual material. But somehow with his extended time spent in the digital trenches of Silicon Valley and with his diligence applied, not unlike the intensity of his subjects, Mr. Menuez has managed to give us an insight into the minds and processes of these (for the most part) enigmatic people who have and will continue to influence our future more than we can imagine. You only have to consider the short trajectory of fifteen years of amazing technological evolution as chronicled in the pages of *Fearless Genius.*

In all great affinity groups, one individual raises above all others and we lesser humans are fascinated to know more about him or her. This is true of groups formed around matters religious (Jesus) or martial (Napoléon); revolutionary (Tom Paine) or cinematic (Marilyn Monroe); geek (Steve Jobs) or gangster (Al Capone); evangelical (Billy Graham) or political (Abraham Lincoln) or mathematical (Isaac Newton). Steve Jobs, a complicated man, surely belongs among the above group of remarkable individuals. His death long before his time compels us to wonder about his inner person. So we are fortunate indeed to have such insightful and intimate access to Steve Jobs and his peers through the exclusive photographs collected in this book.

Mr. Menuez was there, camera in hand, documenting the fundamental period of the digital phenomenon. He was deeply involved with many of its principal players, making the best possible use of his special access and bearing witness to a place, a time, and a people of extraordinary genius.

Introduction
by Kurt Andersen

Like everyone in Silicon Valley in 1985, Doug Menuez was twenty-eight. During the previous four years IBM had introduced the first PC and Apple had brought out the first Mac, and six years hence the World Wide Web would be born. Like everyone else in Silicon Valley in 1985, Menuez was smart and curious and energetic, with a sense that he'd stumbled into exactly the right place at precisely the right time, that the future was being invented by twenty-eight-year-olds staring at screens and pecking at keyboards all over the suburbs south of San Francisco. If he were a poet instead of a poetic photojournalist, he might now be chronicling those giddy days the way William Wordsworth recalled the beginnings of the French Revolution two decades after his idealistic youth in Paris:

Bliss was it in that dawn to be alive,
But to be young was very heaven!—Oh! times,
In which the meagre, stale, forbidding ways
Of custom, law, and statute, took at once
The attraction of a country in romance!
When Reason seemed the most to assert her rights,
When most intent on making of herself
A prime Enchantress—to assist the work,
Which then was going forward in her name!

Menuez, just returned in 1985 from covering Ethiopia's drought and civil war, was looking for a new long-term project that wouldn't involve documenting misery and hopelessness. His contemporary Steve Jobs, just purged from the company he'd founded, was embarking on a new project that wouldn't involve pleasing shortsighted board members and investors at a mass-market computer company. Jobs agreed to give Menuez total access to his nascent enterprise, NeXT, and *Life* magazine agreed to underwrite and publish Menuez's portrayal of the making of Jobs's new new thing. Day after day, Menuez drove from Marin down to Redwood City to hang, chat, and shoot pictures. By the time the NeXT computer was finally ready to unveil three years later, however, Jobs had, um, you know, sorry—changed his mind. "I just decided that *Life* sucks," he told Menuez. "But don't worry—you'll have a great time with these pictures someday!"

As it turned out—as it so often turned out—Jobs's hunch was correct. Because everyone in Silicon Valley knew that *Steve Jobs*, famously difficult and secretive, had given him free run of NeXT, Menuez now had an imprimatur, which for the next dozen years became a kind of all-access backstage pass to the tech epicenter. In his words, he was "a documentary artist with freedom"

to wander around Adobe at the moment Photoshop was created, as well as Intel, Sun, NetObjects, Kleiner Perkins, and Apple. He was in the singular position of being embedded in units fighting on all the various fronts of the digital revolution. What made his free-range access especially remarkable was the culture of Silicon Valley—despite the superficial pizza-and-foosball looseness, the rival tribes inventing the digital future were manic, competitive, prone to extreme paranoia.

During that seminal decade, they dreamed mainly of bringing a cool new world into being, whatever that might mean, of enabling unprecedented communication and diffusion of knowledge and creative expression. Doug Menuez, the son of a Chicago community organizer, was down with that. Utopianism is in the DNA of the Bay Area and has been from its Gold Rush, fairy-tale modern beginnings through the lush countercultural dreams of lifestyle perfection, all fed by coastal California's perpetually pleasant weather and ethos of limitless self-reinvention. *Of course* it was here that the giddy, geeky gearhead tribes took root and flourished at the end of the millennium.

For Northern California baby boomers, even failure could be an opportunity for self-actualization. "The heaviness of being successful," Steve Jobs said of his prodigal-son time after being forced out of Apple, "was replaced by the lightness of being a beginner again, less sure about everything. It freed me to enter one of the most creative periods of my life."

No place on earth is more baby-boomerish than Silicon Valley, and Jobs was its avatar: a CEO who wore jeans and emitted a "reality distortion field," a sentimental, countercultural romantic who was also a ruthless mogul, a forever-young tinkerer dedicated to erasing the old distinctions between tools and toys, work and

play. (To see what the previous generation of Silicon Valley tech guys looked like, see Menuez's portrait *Engineers at Beckman Instruments. Fullerton, California, 1989,* on pages 136–37.) And, no coincidence, it was precisely during the era depicted here that all the boomers—the youngest twenty-one in 1985, the oldest fifty-four in 2000—occupied the sweet spot of the culture and the economy, no longer children but not yet old, equipped with the means and the will to reshape the world. One big reason John Sculley is not a hero of the Silicon Valley story: he was not just an outsider but a generation too old, already forty-four when he became the CEO/designated driver of Apple.

Doug's images are extraordinary, deeply evocative of an unpicturesque virtual circus, as he has an artist's ability to suggest the drama and passion beneath the office-park banality. But they're also deeply ironic. In a region rich with sunny natural greens and blues and golds, he chose to shoot almost entirely in black and white and indoors, a self-consciously old-school portrayal of the new dawn. And he was documenting the digital revolution on *film* just as that revolution was about to make his nineteenth-century medium obsolete.

When you embark on an open-ended project such as this, how do you know when you're done? For Doug Menuez, the beginning of the end was unambiguous. The Netscape browser appeared in late 1994, the work of a hacker fresh out of college who'd moved from Illinois to Mountain View. *Eureka!* For the first time anyone and everyone had free and easy access to the World Wide Web. Connected computing was real! Information wanted to be free! Back in the summer of 1995, when an IPO and monetization were unfamiliar concepts to people outside finance, Netscape went public; a company that had been valued at $21 million less than a year earlier was suddenly worth $2.9 billion. And the Silicon Valley zeitgeist underwent a seismic shift. The young people dreaming up software and devices changed from tech-for-tech's-sake pioneers to guys in the middle of a gold rush. They hadn't all been underpaid, madcap tinkerers before, and they weren't all exit-strategizing money-grubbers afterward, but the calculus changed suddenly, profoundly, irretrievably.

For Doug Menuez, "the final moment was the cratering of NetObjects." That was the start-up in Redwood City whose Fusion software enabled regular people to build websites. NetObjects had its IPO in 1999 and, just before the dot-com bubble burst, achieved a value of $1.5 billion, fifty-one times its revenue—ten times Google's multiple today. "It was the end of an era," Doug says. "I was done."

Part two of the digital revolution began, the part that's all about advertising and ubiquity, little apps and massive scale, about building on the tinkerers' late twentieth-century breakthroughs to create a vast new industrial complex. When Doug Menuez began shooting pictures in Silicon Valley, there was no Web; practically nobody had a cell phone; Larry Page and Sergey Brin were in junior high; and Mark Zuckerberg was an infant. When Menuez finished fifteen years later and moved on with his 250,000 negatives (the equivalent of forty-five pictures a day, every day), almost half of Americans were internet-connected and cell-equipped; Page and Brin had started Google; and Zuckerberg was a high school student hacking software for a music player and an instant-messaging system. Part two has been astounding. But part one, the heedless, more innocent era of *Fearless Genius*? "Bliss was it in that dawn to be alive."

A Trillion Lines of Code
by Doug Menuez

In the last decades of the twentieth century, a brilliant, eccentric tribe sparked an explosion of innovation that today we know as the digital revolution.

For fifteen years I documented the efforts of this tribe, made up of engineers, entrepreneurs, and venture capitalists, as they invented technology that changed human behavior, culture, our very sense of ourselves. Their habitat was Silicon Valley.

Living in their midst as unobtrusively as I could manage, I created a visual record of their everyday lives. They gave us powerful new tools that unleashed our innate creativity and launched an economic expansion the scale of which the world had never before seen.

I was as surprised as anyone that my life in photography—from shooting street life in New York City to art school in San Francisco to a career in international photojournalism—took me to Silicon Valley. However by the mid-1980s, I was ready for something unexpected. I was burning out on the tragic nature of the stories I had been covering—the crises of AIDS and homelessness, the Oakland drug wars, devastating floods, forest fires, and earthquakes. I'd seen my share of suffering and death. In the spring of 1985, I traveled to Africa for the first time and covered a famine caused by civil war and drought. That human catastrophe was almost incomprehensible to me. Despite being a seasoned news photographer, I began to question what I was doing. I began looking for a subject that might suggest a more positive future for the human race. You could throw a stone in any direction and find injustice and sorrow. But if I

could find something that was hopeful yet meaningful in a tangible way for the world, by photographing that I thought I might also find meaning in my own life. Enter Steve Jobs.

I remember hearing that Steve, at the height of his precocious fame and power, had been forced out of the company he cofounded, Apple Computer. He was starting over with a new company called NeXT and was intent on building a supercomputer that would transform education. His plan was to put the power of a mainframe into an affordable one-foot cube a student could use. That got my interest because I had seen firsthand on many magazine assignments how education could have a determinative, root impact on solving so many social issues. This could be the subject I was looking for. Steve had changed the world once already with the introduction of the Apple II and Macintosh, and I thought he might just be able to pull it off again. The stakes were high.

I reached out to Steve through a friend and was soon able to propose my idea to NeXT creative director and cofounder Susan Kare. I asked that I be allowed to follow Steve and his team over the next few years, with complete access, as they designed, built, and shipped the NeXT computer. Along the way I hoped to understand his process for innovation. Susan said my timing was perfect as Steve had been thinking about doing some-

thing along these lines. He fully believed they had a shot at something historic. A meeting was arranged.

At the same time, I suggested to Peter Howe, then picture editor at *Life* magazine, that Steve was an avatar for a new generation of idealists then flooding the Valley. By photographing him, I would learn just how he was able to build breakthrough products and hopefully gain insights into the larger story of Silicon Valley. He agreed to a rare open-ended assignment; now I had only to convince Steve Jobs.

So in the fall of 1985 I drove down to Palo Alto to meet with Steve and his team. I parked at their nondescript office building near the Stanford campus. Before Pixar, the iMac, iPod, iPhone, and iPad, and the greatest comeback in American business history, Steve Jobs was inside beginning a struggle that no one could have predicted would last over a decade. His long journey into a dark wilderness of bitter disappointment and failure was still to come. Years later, from the ashes of NeXT came the seeds of a reborn Apple that would propel Steve permanently into history. I didn't yet have a clue what was ahead, but I was determined to record whatever happened.

As I entered the building, Susan was coming down the stairs to greet me with NeXT's sales and marketing VP, Dan'l Lewin. She said they had already met with Steve and he was all for the idea. There was to be no oversight, I could just shoot whatever I wanted. I was stunned by this good news. Steve came down the stairs as I was soaking all this in and gave me a big smile. We talked for a minute about the project, then he shook my hand and said, "Okay! Great!" and continued on down the hall. I was in. I lifted my camera and went to work.

Steve's generation was shaped by the sensibilities of the sixties and years of economic growth. During this unique period of history, these new iconoclasts were disrupters,

clashing with the pioneering space-race engineers already in the Valley. The older technologists had a worldview forged from constant crisis: World War II and the Korean War, the Cold War and the rise of nuclear weapons, the shock of *Sputnik* and subsequent push for the exploration of space. Many of the companies they worked for developed systems and products for NASA and the Department of Defense. They came to work in suits and ties with buzz cuts and maintained a military-style discipline.

The newcomers wore their hair long, dressed in sandals and jeans, and were determined to harness the power of technology to give ordinary people access to computers. With his new company, Steve wanted to take his vision of easy-to-use computers specifically to students and educators, giving them the power to compute, to create, and to express ideas faster and better than ever.

After three intense years at NeXT, culminating in the October 1988 launch of the NeXT computer, I reached a bittersweet milestone when Steve and his PR team decided to kill the *Life* story. He felt *Life* was no longer "cool," and anyway they had offers for over eighty other magazine covers to choose from for the launch story. It was hard to let go of all that work, but Steve gave me a glimpse of the bigger picture and convinced me that someday this work would come out. And so with Steve's continued encouragement, I decided to expand my project to include as much of Silicon Valley as I could.

Because Steve had trusted me with complete access to his company, so did many of the other leading innovators of Silicon Valley, such as Adobe founders John Warnock and Chuck Geschke; Steve's nemesis at Apple, John Sculley; venture capitalist L. John Doerr of Kleiner Perkins; Bill Gates of Microsoft; Carol Bartz at Autodesk; Bill Joy at Sun; Gordon Moore and Andy Grove at Intel; Marc Andreessen at Netscape; Samir

Arora at NetObjects; and over seventy other leading innovators and companies.

I photographed various hardware companies building everything from PCs, workstations, mainframes, Cray supercomputers and pen-based handheld computers, to virtual-reality goggles and gaming consoles, to chip manufacturers, communications and networking companies, and software companies with products for desktop publishing, business, gaming and entertainment, security, transportation, health care and education, plus a wide range of internet start-ups and even some biotech ventures. Some companies approached me as word got around about what I was doing, and some I approached, usually after an insider would tip me off to a special project. I always had my regular assignments from magazines and commercial clients throughout those years, and sometimes they overlapped.

I photographed with several concerns in mind. First, I wanted to record the daily lives of the people inside these companies, without PR oversight, capturing moments of interaction between workers while looking for patterns of behavior and emotion. I wanted to understand the human side of technology and was curious about what motivates some people to rise up against seemingly insurmountable obstacles, while others have an overwhelming aversion to any risk-taking at all. Some people started companies and some preferred to work for them. But the Valley seemed to attract a preponderance of those people willing to take risks. Perhaps more than anything else, I was interested in the nature of innovation and wanted to see if I could discover something about how creativity was best nurtured.

Second, I also began photographing objects, documents, and environments. Having studied visual anthropology, I knew that this was data that others might later decode to draw conclusions about this new culture that had come to fascinate me. It came with its own language, social rites, and customs, all of which would soon radiate out to influence the larger society.

I paid particular attention to any outward sign of stress. Showing vulnerability was in contrast to the public image projected by tech companies: a polished veneer of extreme competence, which their powerful PR teams displayed even if facing imminent failure.

I became interested in the role of women and the impact of gender diversity (or lack thereof) in Silicon Valley. Could different worldviews change how code was written, and what might that mean for end users?

During this era, the accelerating pace of innovation was affecting the very nature of work and the structure of corporations. The global business environment became an essential consideration as entire nations scaled up around the development and manufacture of new technology. Although Silicon Valley had become the center of American manufacturing around the time I began this project, as our economy shifted from steel and cars to chips and information, the pace of change was so extreme that even the buzzing factories of Silicon Valley had moved offshore by the time I ended my work. We had left the manufacturing-based economy and entered the information economy.

The title *Fearless Genius* refers to those I observed who had true intellectual genius, usually in math and science, or a kind of genius of vision, combined with a rare ability to boldly pursue the power of their ideas to fruition or failure, risking everything they had—health, sanity, family, career. The sacrifice required to invent new technology was great and not understood by the outside world. Marriages dissolved, mothers raised babies in the labs they never left, engineers went insane,

and one young programmer I knew committed suicide. Some went to jail for fraud. Millions of dollars were lost and billions gained, and failure was as much a part of the process as the staggering success that is more commonly associated with Silicon Valley.

Every once in a while I'd witness a moment of sheer joy or sublime satisfaction, despite the hard work and frustration, as some engineer or team would make a breakthrough. Often, I was completely sucked into the emotional roller coaster they were riding, so I was naturally thrilled for their progress and dismayed by setbacks. The objective role I originally sought as a photojournalist fell away and I began to embrace a more subjective, interpretive approach. I maintained distance but was no longer able to remain completely neutral as I was now part of the team. I wanted them to succeed and build machines all of us would benefit by using.

The radical growth of the PC industry was quickly followed by the rocket rise of the internet. The success of the Netscape IPO in 1995 started a new crazy clock called internet time, where even the manic intensity of the 1980s was not fast enough. Everyone I knew was starting a dot-com or going to work for one. Sadly, the early idealism I witnessed, where engineers would actually say things like "I want to build computers for kids in Africa," soon turned into an unsustainable gold rush for IPOs. The "noble cause" described by Steve Jobs when I started out shooting, which felt interesting, risky, and inspiring to me, was getting hard to find.

As the dot-com bubble collapsed in 2000, it was the end of a singular era, and I decided to close my project, putting my 250,000 negatives in storage for the time being. I needed a break from technology.

In 2004, Stanford University acquired my archive for its library with the goal of preserving and sharing the material with scholars and historians. Their dogged and determined support got me inspired again and has allowed for the creation of this book.

My journey through the Valley as a witness during this pivotal age was undoubtedly naive and cannot be definitive. But the project gave me new purpose. Like most photojournalists, I like to think photographs possess the power to change people's long-held ideas about the world around them, perhaps even encouraging social change. The images I shot in Silicon Valley captured the people who were changing the world and made a record of their lives. That was my mission. It felt useful. I owe a tremendous debt to all those who generously allowed me to photograph them. I hope in some small way this book will help to honor their unparalleled legacy.

The people I photographed were on a mission, too. They knew they'd make money, but that was not their primary goal. They wanted to build cool stuff that would change everything. Many of them wanted to improve the quality of human life. Why is having a mission important? Because money is not enough motivation for most people to walk through fire when things get tough. It's about what is worth doing with your life and what you are willing to gamble to accomplish your dreams. This is the intangible human spirit, a creative force that can't be quantified in the business plan but that might just be the one element every successful breakthrough technology has to have.

To a hardened businessperson, it might sound simplistic or romantic to read my descriptions of the true believers of the prior era and their selfless fight to build new technology. The reality I saw was that nothing got accomplished without that passion, that deep desire to make the thing work.

It is my hope that *Fearless Genius* will foster dialogue around issues related to the development of new tech-

nology and its impact on our lives—and the challenges we now face. Currently millions of science, technology, engineering, and math jobs go unfilled in the United States. We have failed to graduate kids interested in excelling in these fields. Since 2000, no important technology innovation in the United States has been scaled up to create millions of manufacturing, marketing, and engineering jobs here, as personal computers and related industries did. While selling online and social networking are clearly transformational movements that have created entrepreneurial opportunities, fewer than fifty thousand traditional jobs—those with full-time hours, benefits, and health insurance—have been created.

One negative outcome of the dot-com crash was that a giant brake was put on innovation as investors sought shorter-term, lower-risk projects. Although another boom is now under way in Silicon Valley, complete with some cool ideas, it's all about apps that can be released quickly because investors want their money out now in eighteen months. The "patient" money required for difficult, important technology development such as solving climate change has disappeared. The good news is that this lull we seem to be in is probably normal turbulence that happens between twenty-five-year technology-wave cycles. As Apple cofounder Steve Wozniak said, you don't get a world-changing product every year. The technology from twenty-five years ago is only now maturing, and we are starting to see its promise realized on a practical level through tremendously useful and creative products.

And we can see an extraordinary new wave of technology development coming soon that will bring important advances through genomics, nanotech, sensors, quantum computing, 3-D printing, and other new technology. With access to cheap smartphones, a billion people in the developing world are predicted to come online in the next twelve months. This surge of humanity joining the digital revolution will surely result in a creative outpouring of ideas that will blow our minds. We just have to be sure to catch the wave when it gets here.

In my travels, I see the lasting legacy of Silicon Valley innovation in every corner of the world. Every single day I use a laptop, a cell phone, or an app that had its origins in rooms I walked through back in the day. Silicon Valley remains the greatest engine for innovation the world has ever seen. Signs of a new idealism in the Valley are also apparent. For example, Stanford's superhot design school is encouraging the growth of "double bottom line" businesses that offer practical technology solutions to developing countries at affordable prices while still making a profit. An energetic philanthropic movement led by Bill and Melinda Gates has expanded to include newcomers from Facebook, Google, and other companies with their own new foundations and corporate alumni who are doing significant work on such issues as disease, poverty, and education.

We can certainly learn lessons from the digital revolution to help us meet the challenges we face today. The stories of those who built the world we live in now might just inspire the next generation of engineers and entrepreneurs to push beyond the expectations and limitations of our time, to find their own "mission impossible" and render it not only possible but accomplished.

Beneath the vast enterprise and churn, I discovered the joyous, primal urge to invent tools that has driven human progress for millennia. I saw something uncontrollable, hungry, and wild—something human—that still exists in Silicon Valley today. That strain of fearless genius can and will drive a new technology revolution, perhaps even fulfilling the promises of the last one as it lifts its gaze to a world we have only begun to imagine.

"I want some kid at Stanford to be able to cure cancer in his dorm room."

—Steve Jobs, on his hopes for what his new black-cubed NeXT workstation would do

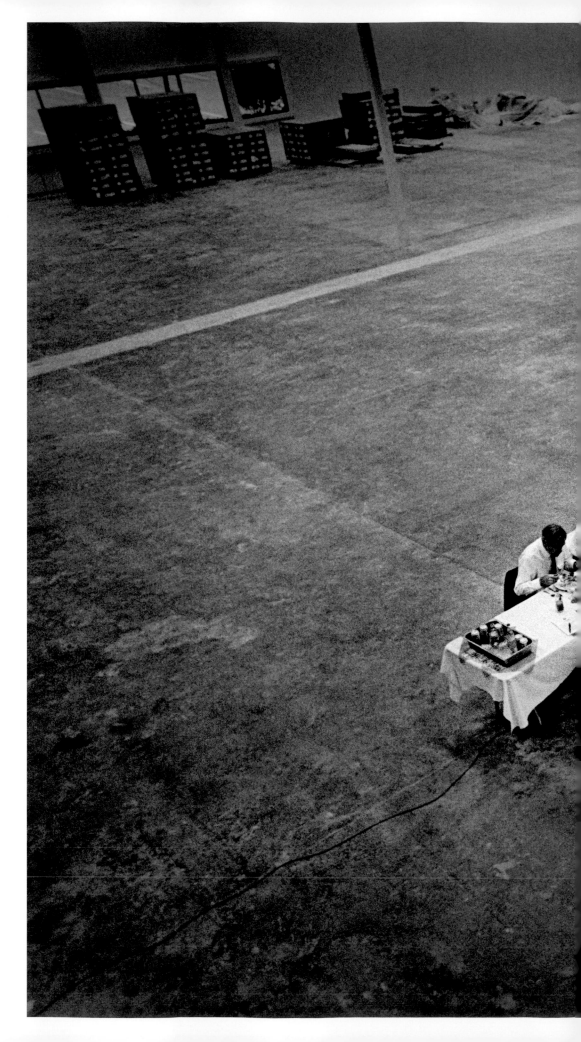

**The Day Ross Perot Gave Steve Jobs
$20 Million.**
Fremont, California, 1986.

Steve was a consummate showman
who understood the power of a com-
pelling setting. This was never more
apparent than at this incongruously
formal lunch he hosted for Ross Perot
and the NeXT board of directors in the
middle of the abandoned warehouse he
planned to turn into the NeXT factory.
He told Perot that they were building
the most advanced robotic assembly
line in the world and that "no human
hands" would be assembling hardware.
He predicted that NeXT would be the
last billion-dollar-a-year company in
Silicon Valley and that they would ship
ten thousand computers a month.
Perot, who was then championing a
movement to reform education in the
United States, was blown away by the
presentation and invested $20 million,
becoming a key board member and giv-
ing NeXT a crucial lifeline.

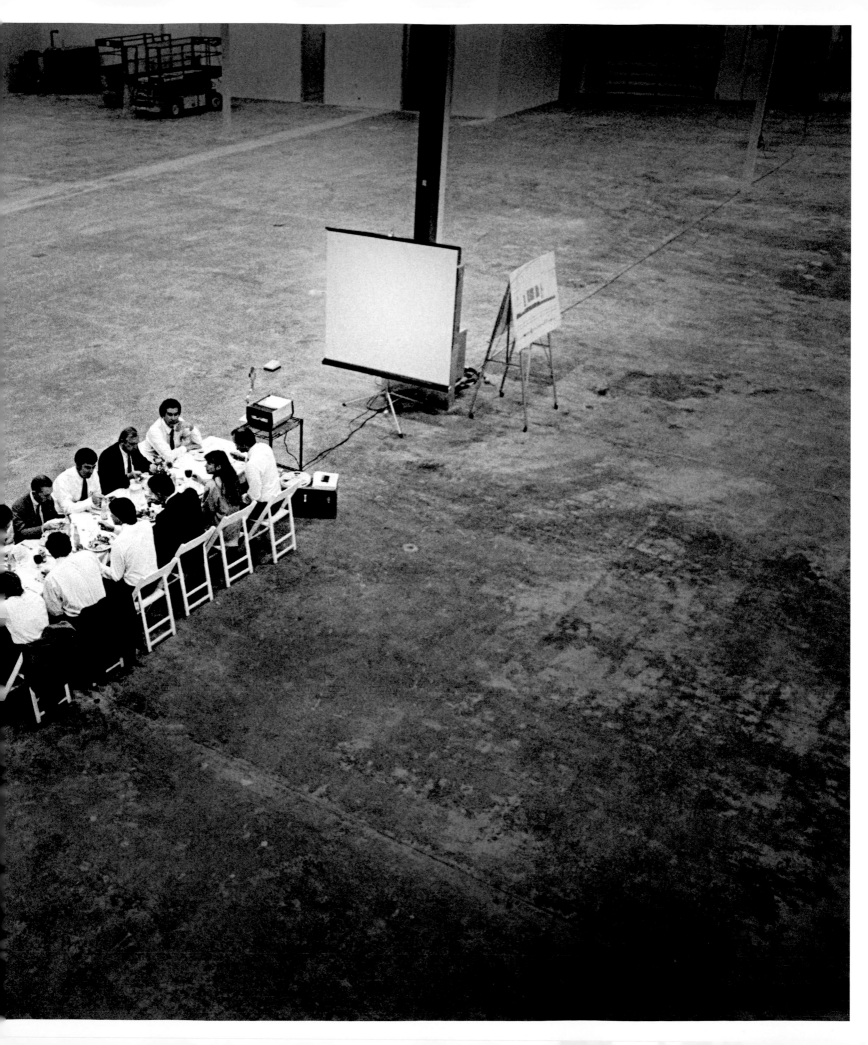

Steve Jobs Explaining Ten-Year Technology Development Cycles.
Sonoma, California, 1986.

Steve giving a history lesson about how technology evolves in ten-year wave cycles to his new NeXT team at an off-site meeting. Every few months, Steve and the fledgling company's employees would travel to a retreat in the country with their families to grapple with myriad technical issues. There he would regularly hold talks to explain his vision for the company and to encourage his brilliant cofounders and employees to participate fully in its realization. Steve planned to ride the next wave by putting the power of a refrigerator-size mainframe computer into a one-foot cube at a price affordable to universities, thus "transforming education." When I asked him what he meant by this, he said he wanted "some kid at Stanford to be able to cure cancer in his dorm room." Because he absolutely believed this was possible, his whole team did. Behind this noble goal, Steve was also on a quest for redemption and revenge after being forced out at Apple in a humiliating boardroom coup after alienating key board members and his handpicked CEO, John Sculley. Most industry pundits believed NeXT would be a huge and rapid success, as did Steve. Instead, it was the start of a decade of difficult, often bitter struggle.

4

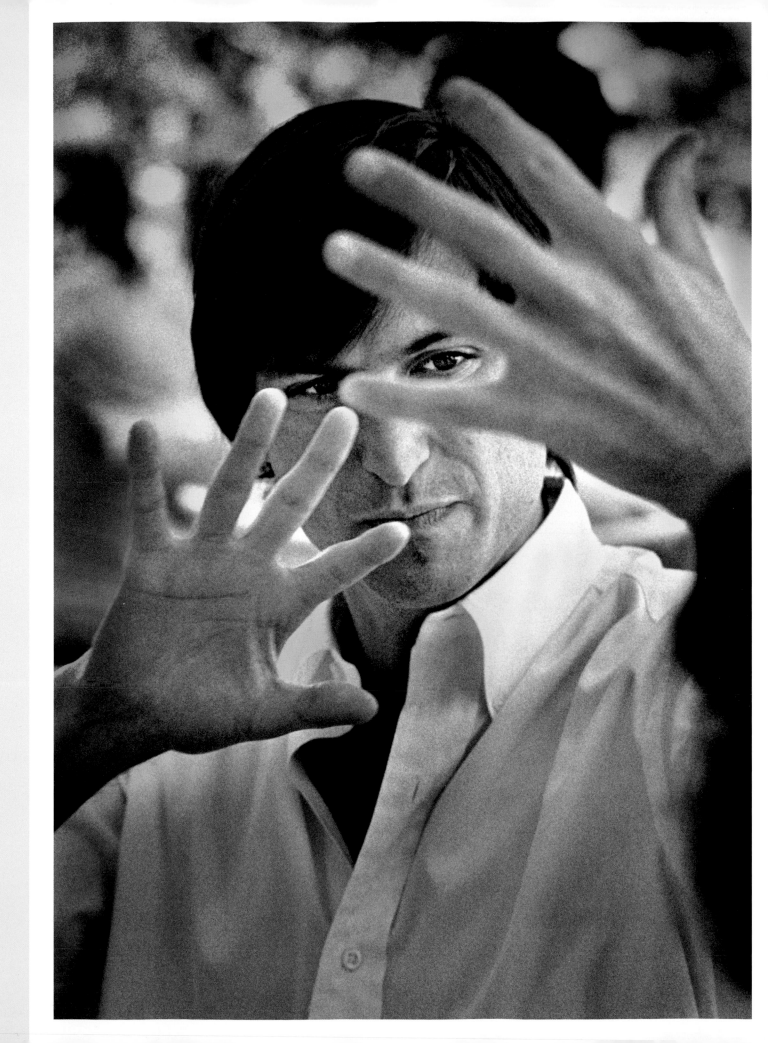

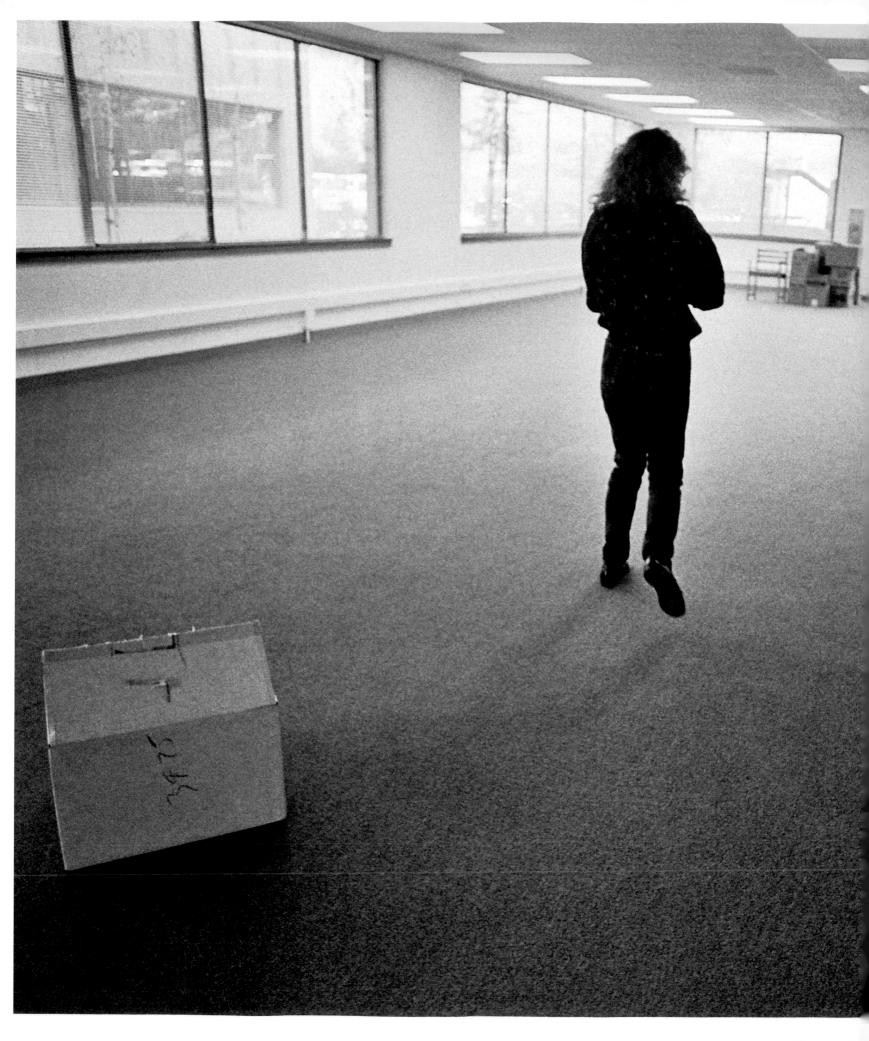

The Start of the Start-Up.
Palo Alto, California, 1985.

NeXT cofounder Susan Kare walking through their brand-new headquarters on Deer Creek Road, where they were still adding employees and transforming the empty space into offices and labs. To succeed in Silicon Valley you first needed a great idea, a brilliant team, lots of money, and a space in which to create the dream. Often, one predictor of failure was the money spent on luxury furnishings at the start. But Steve had started Apple in a garage and was determined to launch his second company with top-of-the-line interior design everywhere you looked. After expanding into luxe offices in Redwood City a few years later, Steve commissioned architect I. M. Pei to build a floating cement staircase.

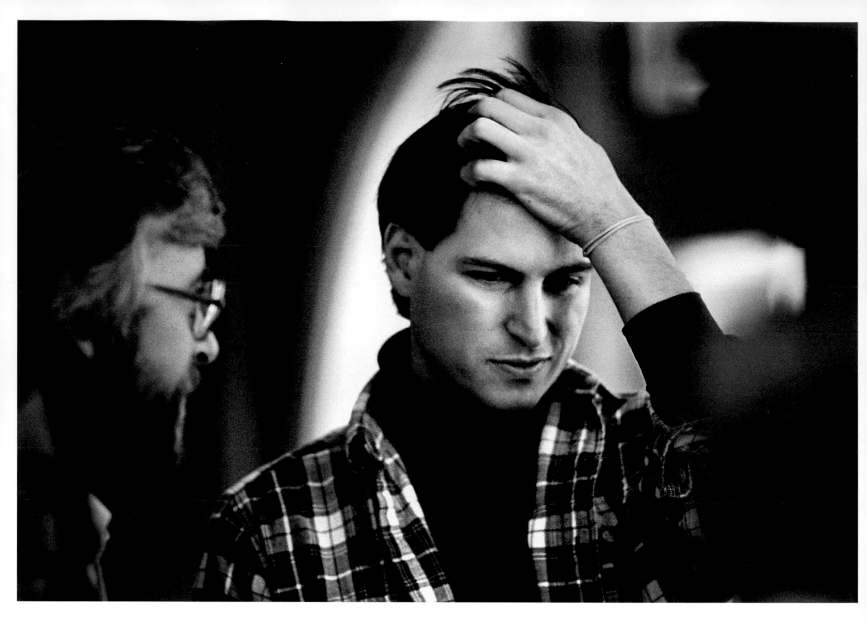

Steve Jobs Considers a Response.

Palo Alto, California, 1986.

NeXT design director Eddie Lee said that Steve had a way of "smiling shit at you" when he was getting mad. His head would go down and he'd make this sort of uncomfortable half smile, and you knew you were about to get crushed. Decisions in early team meetings such as this one were fraught with tension because the team was writing its business plan as it went along. One pivotal decision made was to build both the hardware and the software for the NeXT computer, a vastly harder prospect than their original idea to build only software. While still shaping every detail of NeXT in early 1986, Steve also had the incredible foresight to recognize that something amazing was happening with digital animation at Lucasfilm. He capitalized a new spin-off company with $10 million of his own money. They named it Pixar.

Susan Kare Is Part of Your Daily Life.

Sonoma, California, 1987.

It's not a stretch to say that Susan Kare's playful icons and user interface design have impacted the daily lives of hundreds of millions of people around the world. Susan was part of the original Mac team and designed the original Mac icons and much of the user interface. Leaving Apple with Steve after his ouster, she became a cofounder and creative director at NeXT Computer, where she oversaw the creation of its icons and logo, working with the legendary Paul Rand. Later she designed or redesigned icons for many other computer operating systems, including Windows and IBM's OS/2. Here she's listening to Steve at an off-site meeting with her colleague Kim Jenkins (*right*), as he discusses the unfinished tasks facing the company. Kim, a key member of the marketing team, came to NeXT from Microsoft, where the education division she started was profitable beyond anyone's expectations, giving real competition to Apple, which had previously dominated the education market.

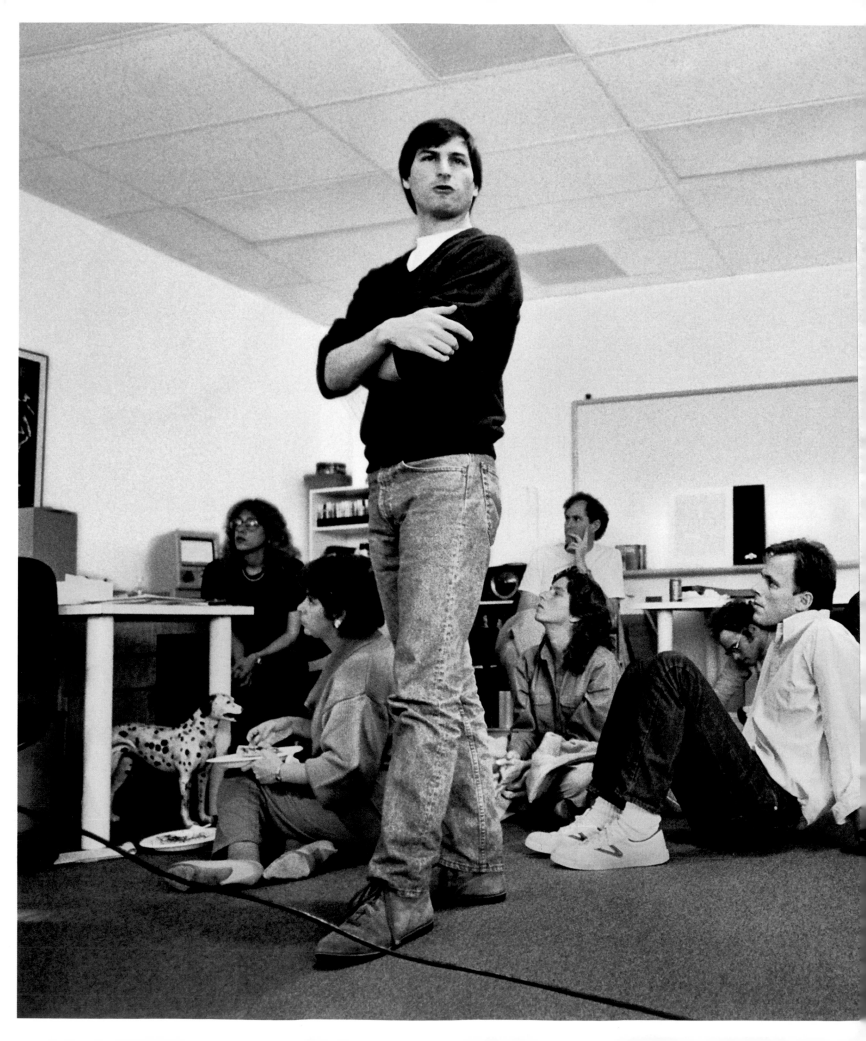

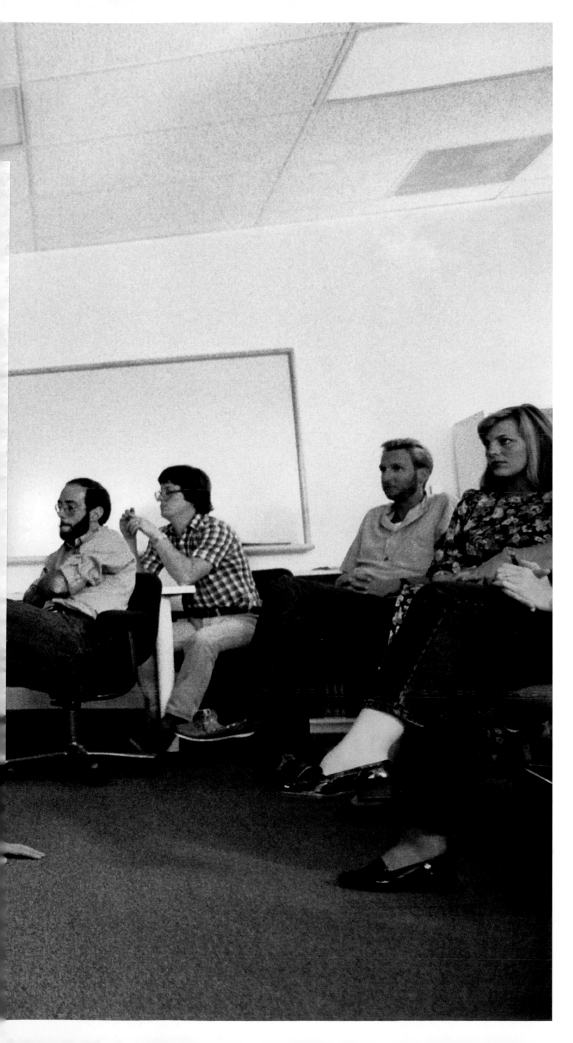

Ninety Hours a Week to Change the World.

Palo Alto, California, 1986.

In the middle of a presentation to the NeXT team, Steve suddenly stopped and said, "Hey, everybody, let's work nights and weekends until Christmas, and then we'll take a week off." One of the engineers in the back of the room responded meekly, "Um, Steve, we already *are* working nights and weekends."

Deep Shit

1. Modem
2. Tester Software
3. Browser
4. Performance Pian
5. Single Drive Cop
6. User Interface

Ankle Deep Shit

The Shit List.

Sonoma, California, 1987.

A Steve Jobs to-do list made at an off-site brainstorming session listing a set of technical challenges remaining for his team to solve. While building the NeXT computer, Steve wanted to meet the challenge that Nobel laureate Paul Berg had set to build an affordable workstation for education that had more than one megabyte of memory, a megapixel display, and a megaflop of computing speed to allow a million floating-point operations per second. Today we measure in gigabytes and gigaflops, but at the time, combining these attributes presented considerable technical hurdles.

Steve Jobs Returning from a Visit to the New Factory.

Fremont, California, 1987.

Although Steve could be extremely rude, critical, and occasionally even vindictive, he also was incredibly joyful, with an infectious grin and energy that was irresistible. In the early days at NeXT, he would often come bounding in, hungry to get to work. Still, there were not too many unrestrained moments of hilarity such as this one, when Steve was riding back from a visit to the newly chosen factory site with the company employees in an old, rented yellow school bus.

14

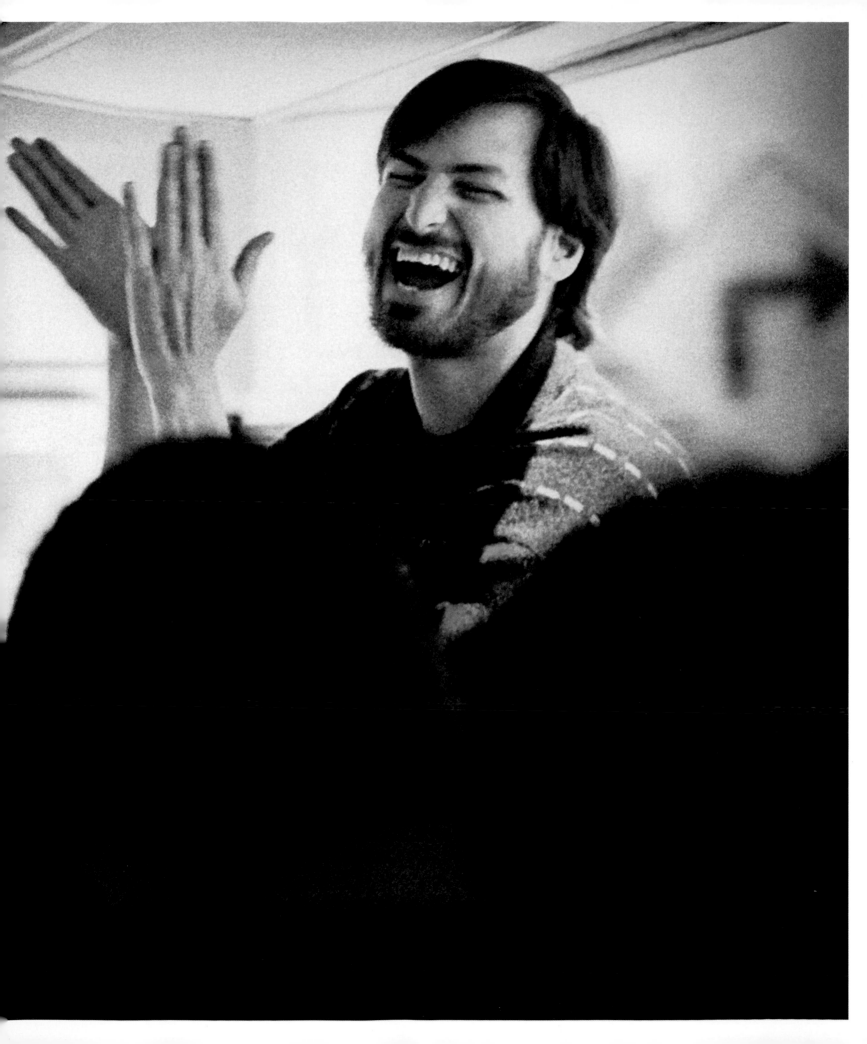

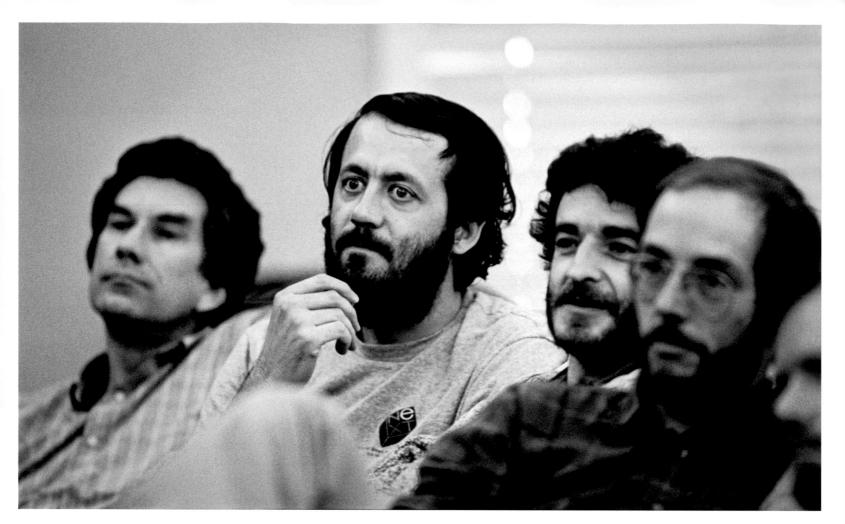
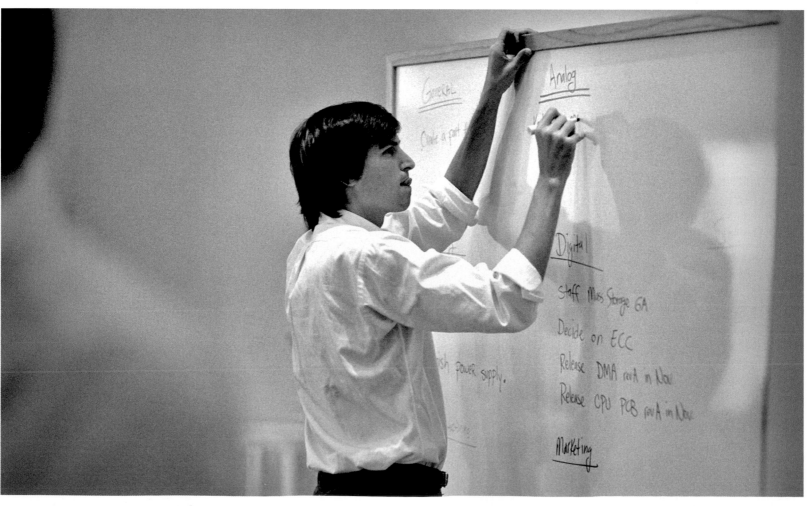

Bending the Laws of Physics.

Santa Cruz, California, 1987.

NeXT's team of engineers, all leaders in their respective fields, were often stunned at the technological challenges Steve demanded that they solve. One engineer was described as "spitting mad" while arguing with Steve, but most of them also relished the challenges Steve posed. At a company off-site meeting, from left to right, NeXT cofounder and vice president of analog hardware engineering George Crow, NeXT cofounder and vice president of digital hardware engineering Rich Page, and software engineers Jean-Marie Hullot and Jack Newlin.

Steve Jobs Outlining the Digital Revolution.

Sonoma, California, 1986.

Steve lists the workflow ahead for his team at a company meeting at a Sonoma resort. His outline included everything that remained to be converted from analog to digital. Indeed, everything in the world that was not by then digital would soon be, as the digital revolution raced ahead.

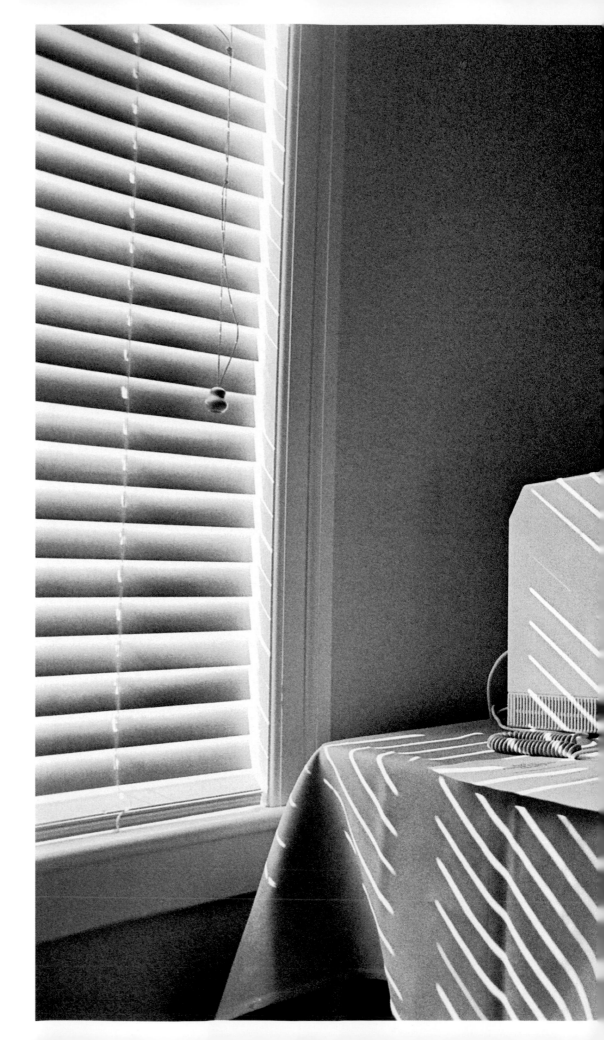

Sunlight.

Sonoma, California, 1986.

At tech start-ups it was rare to get outside or even see the sun for days at a time. A young NeXT employee working on an early Macintosh at a company retreat focuses on the task at hand, closing the shades and ignoring the insistent sunlight she has no time to enjoy.

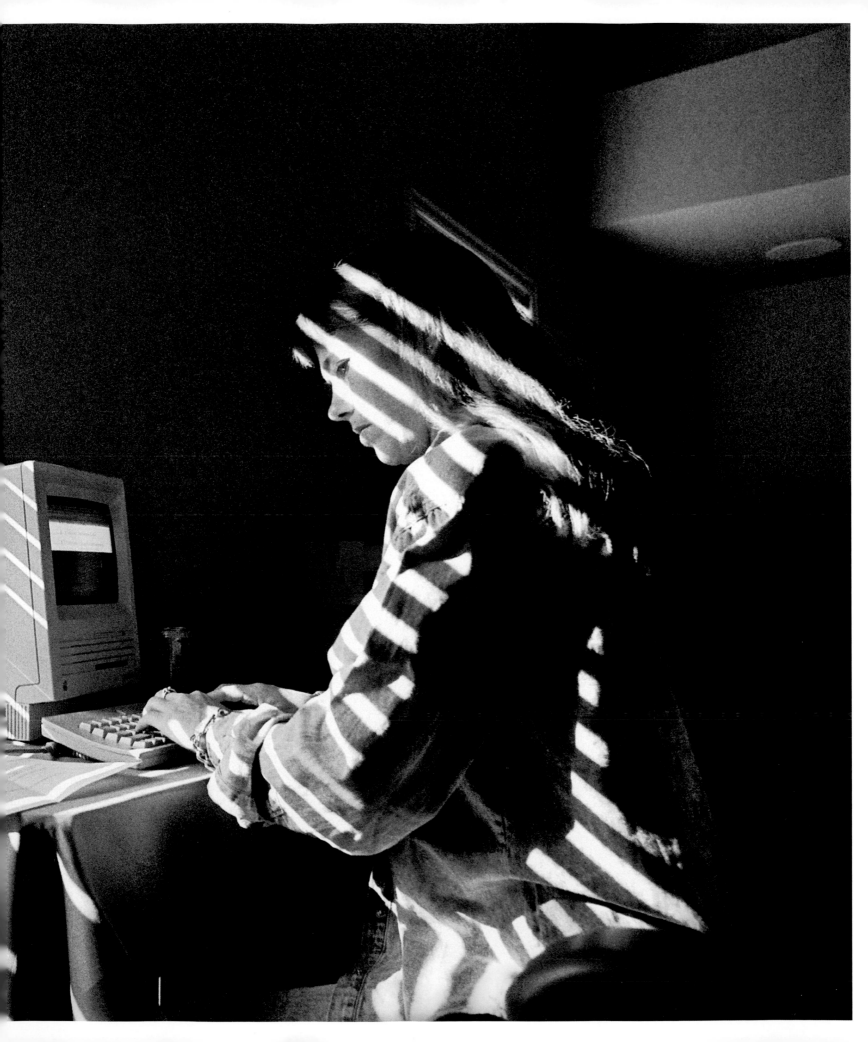

Steve Jobs Pretending to Be Human.

Menlo Park, California, 1987.

Steve was not the kind of guy who ever seemed to relax. He was usually focused like a laser on the task at hand. So it was surprising to see Steve kicking this beach ball around at a company picnic. He seemed to be having a good time, but it felt more like a performance designed to encourage the team to relax. He knew well from previous experience that his team needed breaks in order to sustain the forced march that would culminate in shipping the product.

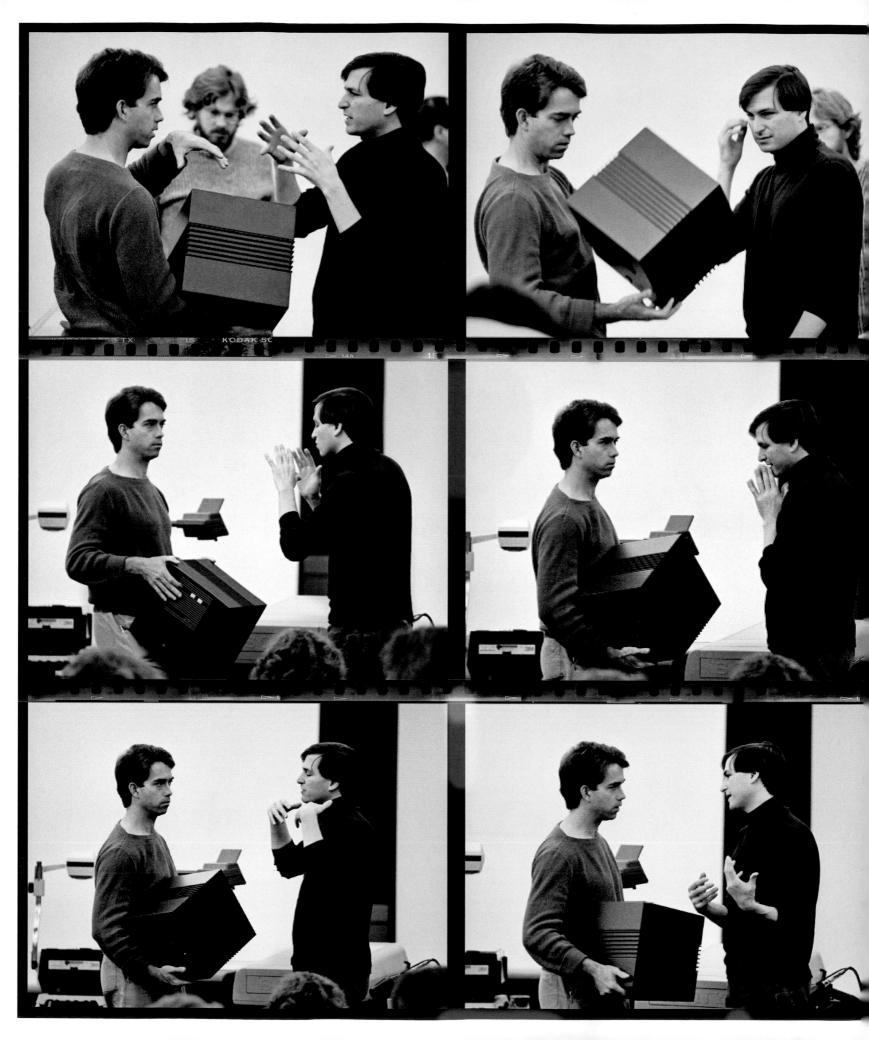

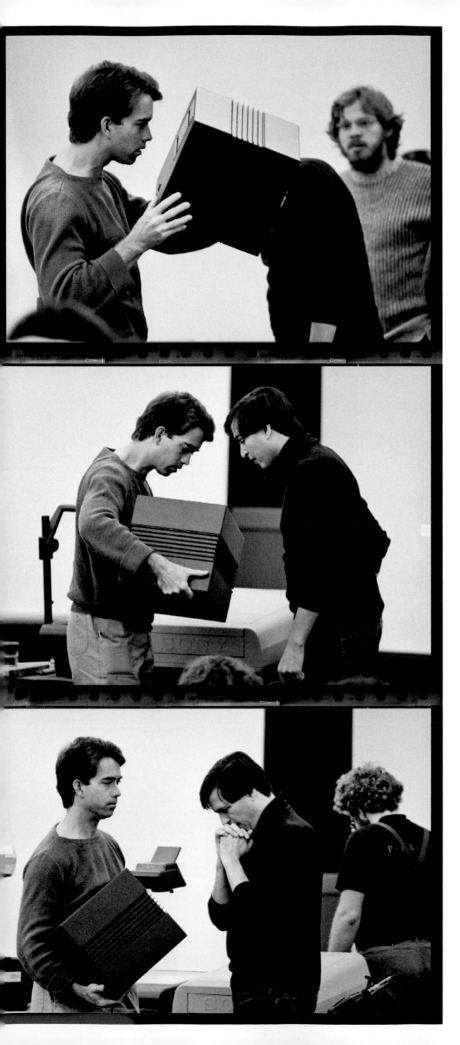

Steve Jobs Views the NeXT Computer Case Prototype.
Santa Cruz, California, 1987.

A rare view of Steve Jobs in action, in this case agonizing over the surface texture of the anodized cast-magnesium cube for the NeXT computer with Ken Haven, director, mechanical engineering. Magnesium is lightweight and strong, but the complications of manufacturing the cube to Steve's exacting standards were quickly adding to the costs and delaying the product. Part of his process was based on his need to trust. Steve was sometimes ruthless because he understood the stakes and knew that each of his thousands of decisions mattered—if the majority were correct, it could tip the project to success, but if not, to rapid failure. He had to trust that the person presenting a solution or an option had thoroughly done his or her homework before Steve could gamble on the suggestion. That might mean twenty minutes of intense shouting until he was satisfied. Then a switch would flip in his brain and a big smile would break out. "Okay, great," he'd say as he turned to the next issue. Often, people would shout back, giving as good as they got, which Steve appeared to appreciate and encourage, saying he wanted to work with people with strong character. Eddie Lee described his interactions with Steve as one of the greatest experiences of his life. Sure it was tough, he says today, but he never took it personally because it was always about "making the thing better."

Evolution of the Species.
Palo Alto, California, 1988.

This cheeky tableau of a robot dominating a primate seen decorating a cubicle at NeXT is symbolic of today's big debates in Silicon Valley about nothing less than the future of humanity. As the pace of technological innovation is expected to increase exponentially, experts believe that the next stage of our evolution will see humans actually merging with machines. Today exciting advances have already been made in artificial intelligence, nanotech, and genomics that when put together might lead to this outcome. But a minority of concerned scientists are now speaking out in books and at conferences, expressing their fears that these technologies might threaten our future as a species. Virtual-reality pioneer Jaron Lanier worries that in the future we'll be able to upload our brains into a "hive mind." We'll leave our bodies behind to achieve immortality, but will end up working forever as slaves tasked with writing free *Wikipedia* entries all day.

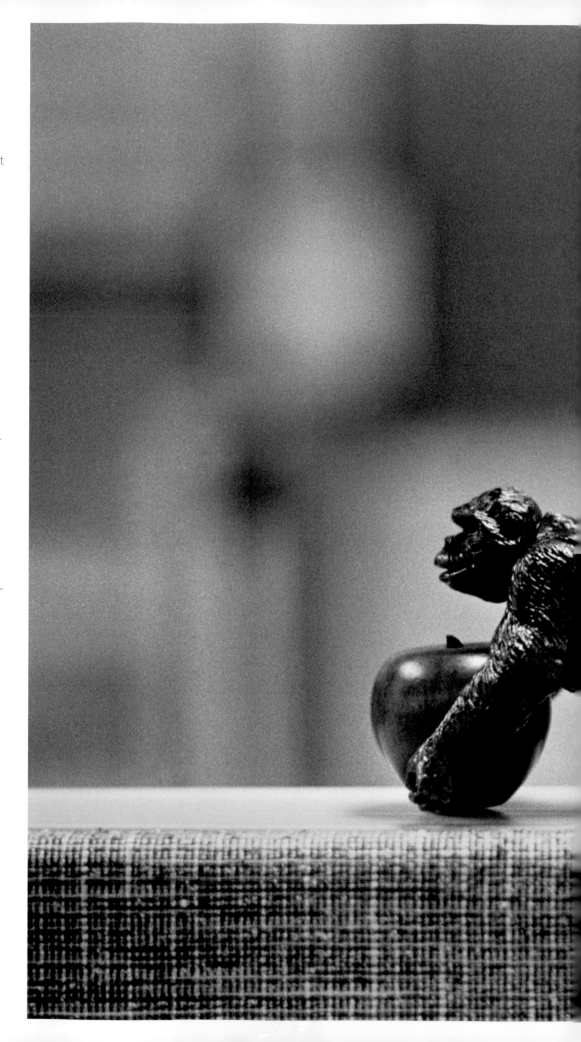

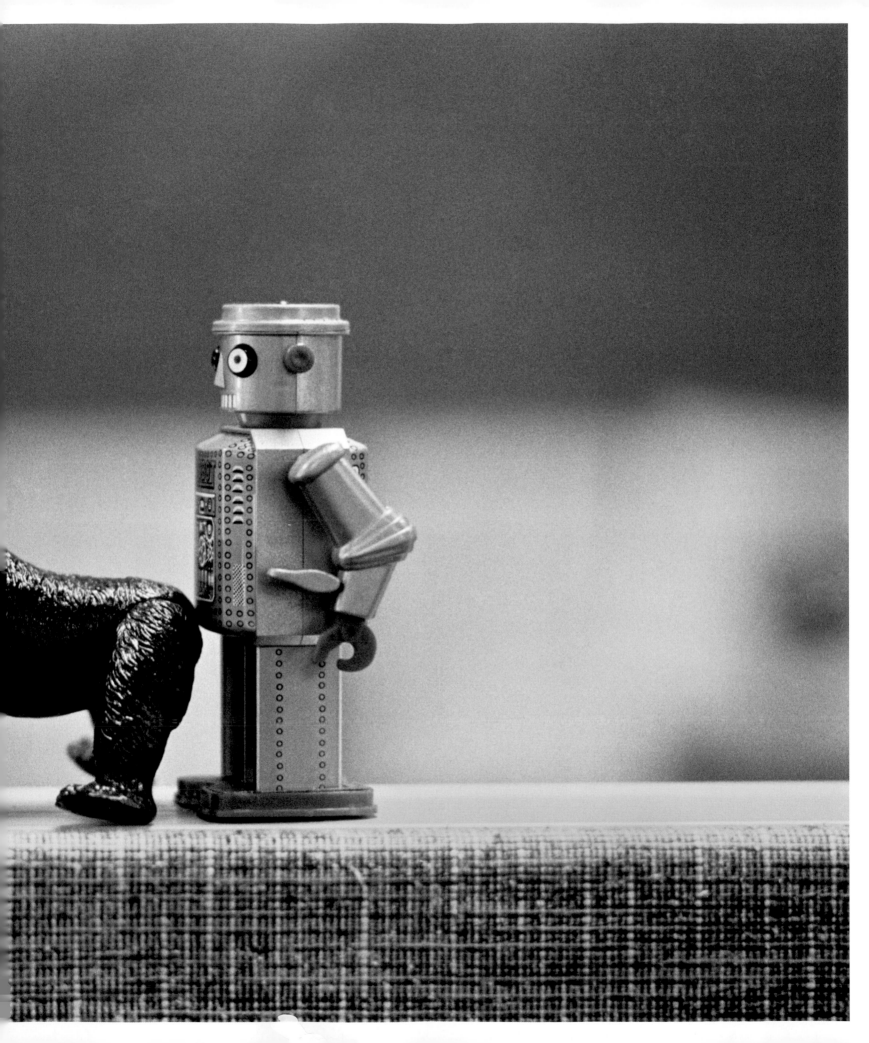

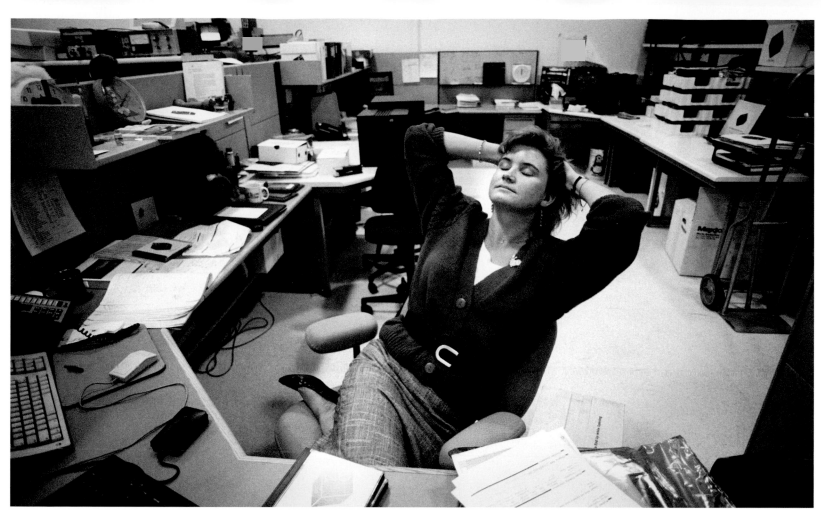
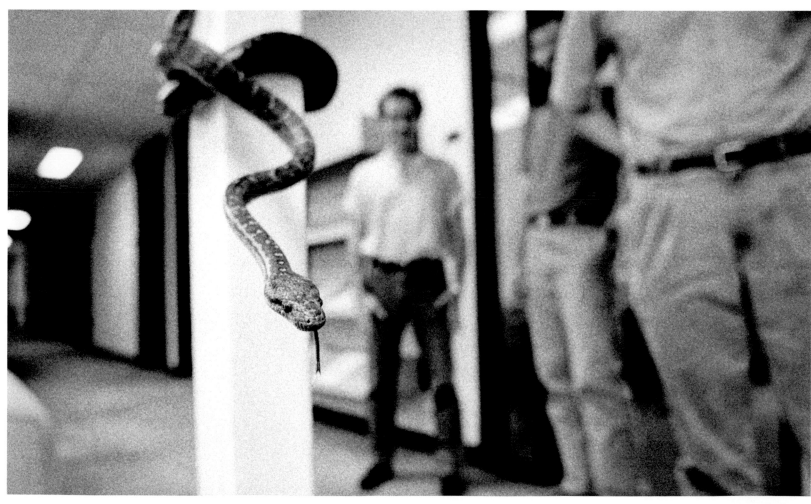

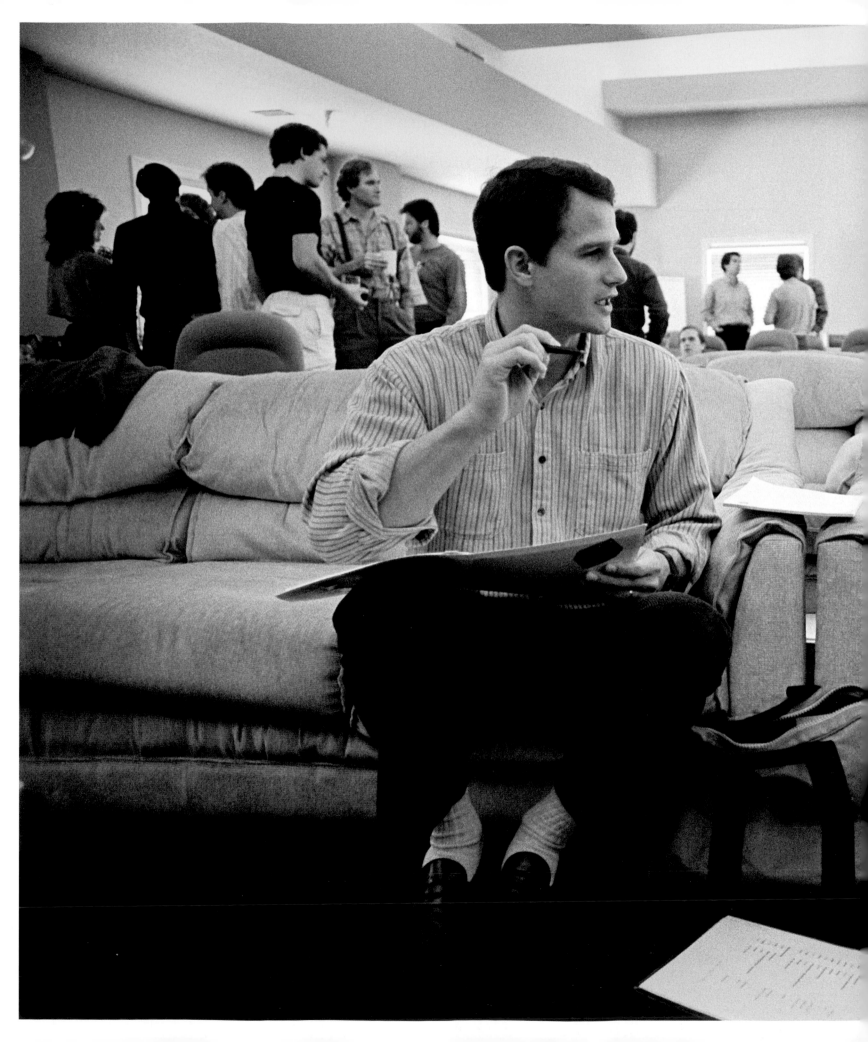

Previous Spread
NeXT Days, NeXT Nights.
Palo Alto, California.

Step by step the company makes progress. *Clockwise from top left:* In Redwood City, 1988, NeXT manufacturing engineers examine a circuit board fresh off the advanced robotic production line at the NeXT factory; service coordinator Paula Lorenz takes a break (without leaving her desk) from her work at the NeXT factory, Fremont, 1990; in Redwood City, 1998, engineers watch colleague John Anderson's free-roaming pet boa; in Palo Alto in 1987, software engineers Trey Matteson (*on floor*) and Chris Franklin (*standing at computer*) and colleagues are working near the sunny rooftop hangout area they called Silicon Beach.

How to Sell Ten Thousand Workstations a Month.
Santa Cruz, California, 1987.

At a NeXT off-site meeting at a Santa Cruz resort, Steve presented Dan'l Lewin with a newly devised and wildly ambitious manufacturing plan. He then demanded that Dan'l and his sales and marketing team instantly create a sales strategy to match it and present it to the company. That day. Dan'l later told me, "Steve had a binder he was waving around saying, 'Look what Randy did, this is brilliant' and 'You guys now figure out how to sell ten thousand units a month.' I gathered my team and said, 'Okay, let's have some fun with this. Let's do Plan One Billion.' We did the math, and to generate one billion in revenue we'd have to have a two-hundred-person sales organization. Steve's fantasy was that by some magical date we would be shipping the ten thousand from Randy's plan." At this point the factory had not even been built. Still, Dan'l and his group quickly devised a rousing, theatrical presentation of Plan One Billion, replete with props such as a bowie knife, Barbie dolls, and a dozen eggs, which he cracked into a bowl onstage. He then dumped everything into what appeared to be his briefcase. The presentation satisfied Steve and was cheered by their colleagues.

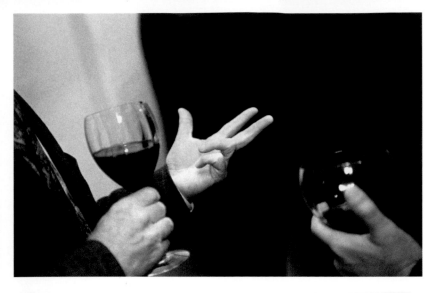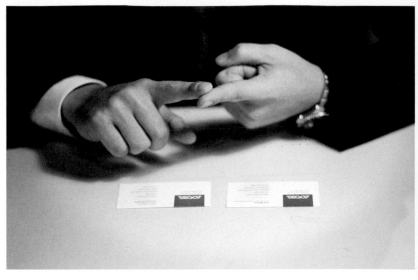

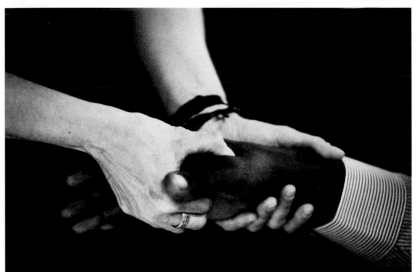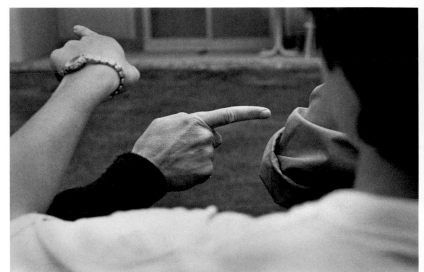

Only Connect.

Silicon Valley, California.

So much of life in Silicon Valley was about explaining and selling ideas—to investors, to colleagues, to the press. I grew to love watching hands as a way to understand the emotional state of my subjects. *Clockwise from top left:* Farallon Computing, Emeryville, California, 1990; Adobe Systems, Tokyo, Japan, 1991; Adobe Systems, Mountain View, California, 1989; NeXT Computer, Palo Alto, California, 1986; NetObjects, Redwood City, California, 1998; Dupont salesmen, Maryland, 1991; Kleiner Perkins, Aspen, Colorado, 1996; Farallon Computing, Emeryville, California, 1990.

Steve Jobs Is Thinking.
Santa Cruz, California, 1987.

Steve was a technologist, an editor, a cool hunter, and a savvy businessman, but he also had an artist's intuitive mind, dreaming up new ways to combine existing technologies to create something completely new. Mostly, he was staking out virgin ground at the intersection of the humanities and science. Another of the many attributes that set him apart was his refusal to take no for an answer. Steve surrounded himself with the most brilliant scientists, marketers, and managers on the planet, sometimes interviewing a hundred people for every one he hired. Then he pushed them, sometimes kicking and screaming, to do what they thought they knew was impossible—until they somehow rose above their own considerable talents to deliver the miracles Steve demanded. Despite the unhappy fate of the NeXT hardware, he never gave up on his ideas. The innovations he engendered during the NeXT years would be the key to his triumphant return to Apple.

Loose Lips Sink Ships.
Redwood City, California, 1988.

Shortly before the official launch
of the NeXT computer, Steve
had the completed prototype
computer, screen, printer, and
peripherals working in his office.
He kept them covered in black
velvet to keep them hidden
from visitors. Tech companies
were extremely competitive and
secretive, so precautions were
taken even behind closed doors.
As you entered the original NeXT
building in Palo Alto, visitors
and employees were greeted by
a vintage World War II British
poster warning that "enemy
agents" were in their midst and
to avoid "careless talk."

Exhortations, Incantations, Promises, and Threats.
Redwood City, California, 1988.

Steve gives a rousing pep talk to inspire his weary employees while also indulging in a short rant about revenge on Apple and John Sculley. The company was preparing to demonstrate the NeXT prototype at gala demonstrations in San Francisco and Washington, DC, although it would be almost another year before finished workstations would be shipped.

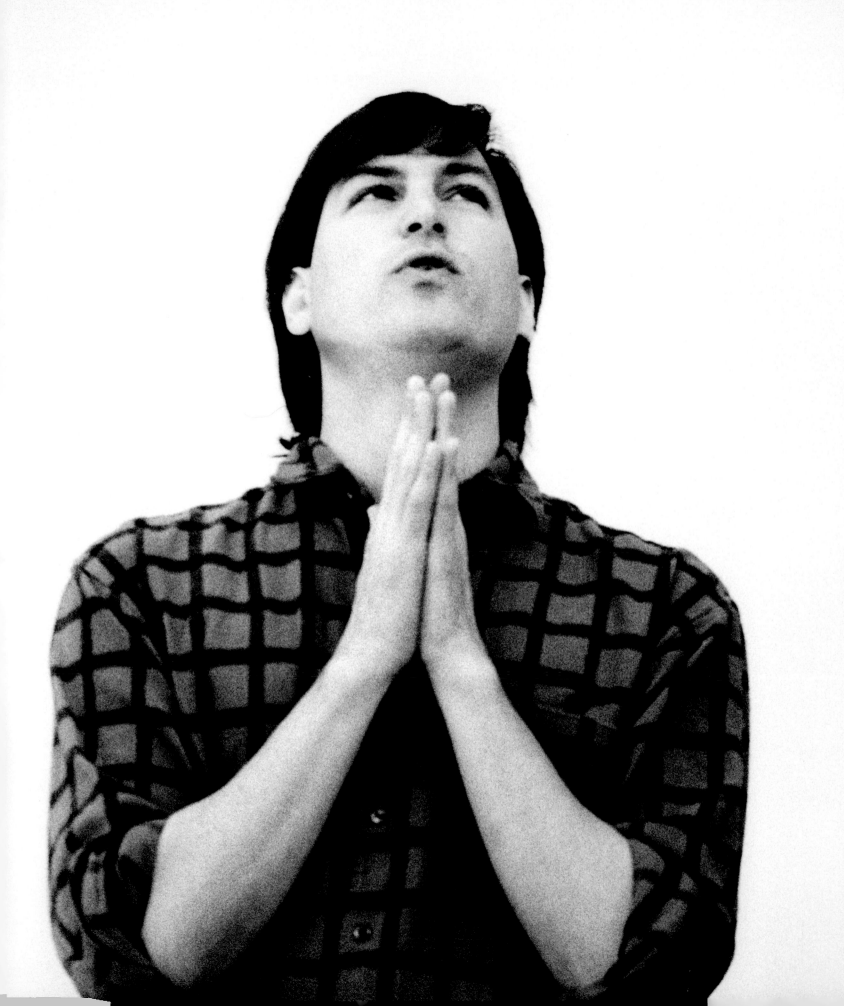

You Catch More Flies with Honey.
Washington, DC, 1988.

NeXT board member and early
investor Ross Perot charms fans
and potential customers from
higher education at the Smithson-
ian Air & Space Museum during
the East Coast launch of the NeXT
workstation. Once, while watching
Steve berate an employee, Ross
said, "Steve reminds me of myself
when I was his age [thirty], but then
I learned you catch more flies
with honey."

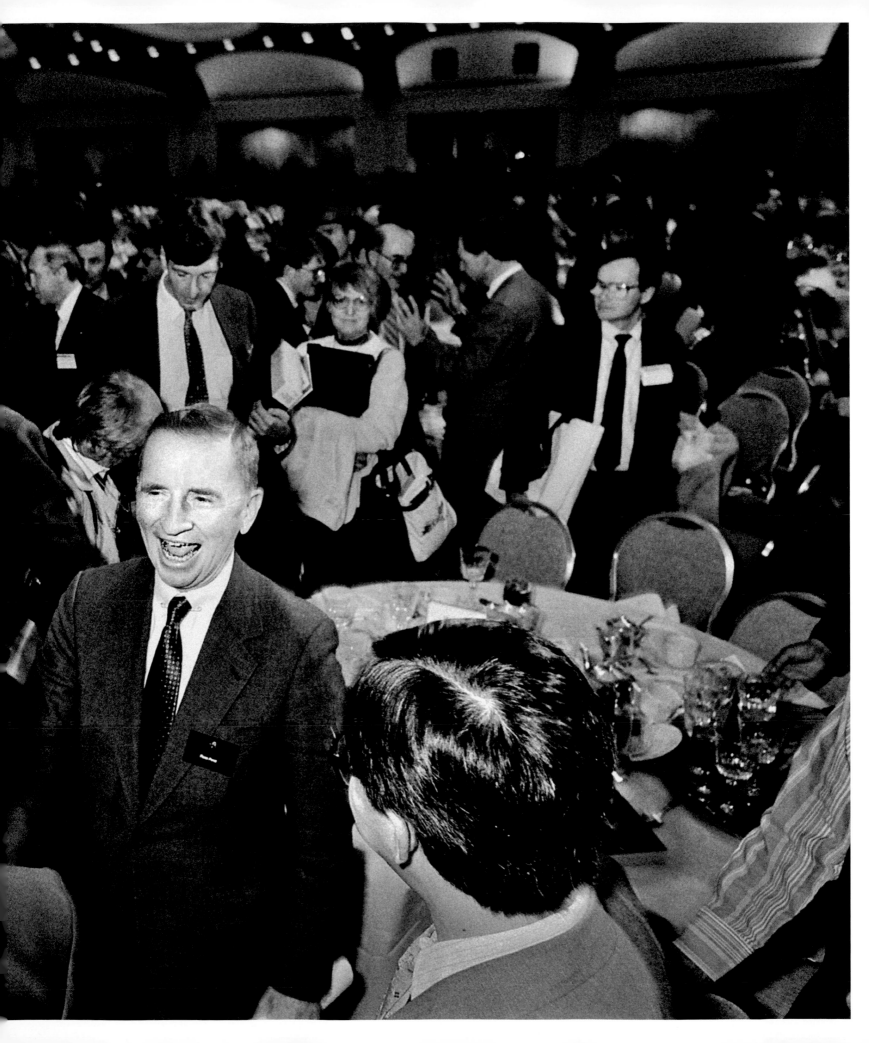

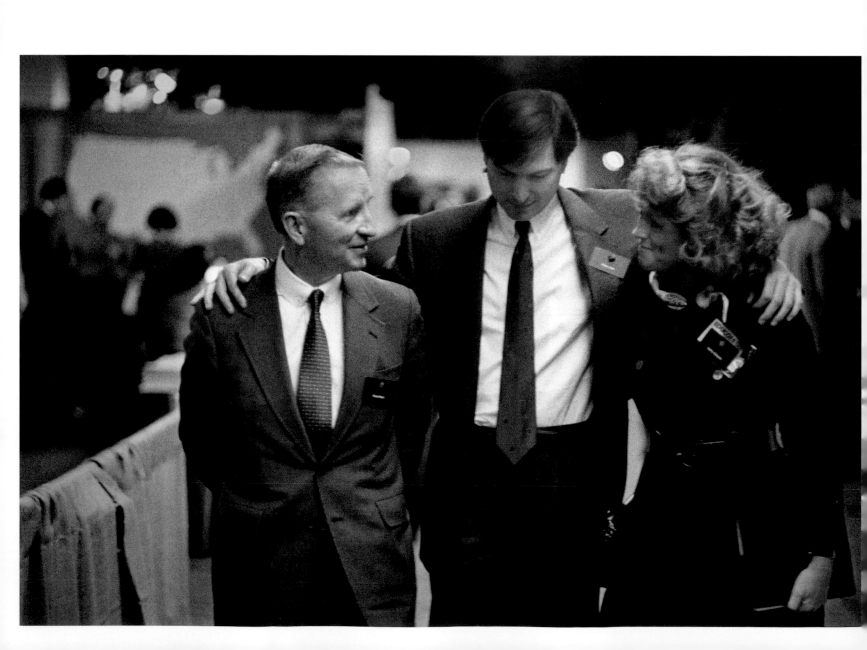

The End of the Beginning.

Washington, DC, 1988.

Ross Perot, Steve Jobs, and NeXT marketing executive Kathy Kilcoyne enjoy the brief afterglow from a promising series of days presenting the NeXT workstation to their key market at Educom '88. After three years of exhausting, almost superhuman development with his small team, Steve Jobs's redemption and return from the technology wilderness seemed at hand. It was not to be. The launch was a massive PR success, but ultimately his key partners in education felt betrayed by the workstation's $6,500 base price, more than double what was promised. This was just days after the glittering San Francisco launch, and Steve and his team were utterly spent, yet still months away from having a finished product. Sadly, the company slowly faded as sales stalled. The company was late to market, faced fierce competition from former partners such as Sun Microsystems, initially lacked a color monitor, and used the Canon optical disk drive for storage—revolutionary and cool, but frustratingly slow. Steve had to close the NeXT hardware division in 1993 in a painful, public failure. A few years later, he'd almost run thorough all his money between funding NeXT and Pixar and was close to broke. But then Pixar released the megahit *Toy Story*, and the subsequent Pixar IPO made him a billionaire. And the intense effort at NeXT finally paid off: the software was years ahead of its competition, and in 1996 Apple bought his object-oriented operating system called NeXTSTEP. This allowed Apple to innovate again and became the basis for the OS X operating system found today in all its products. Steve gained a seat on the board and was soon back running Apple. He began releasing one successful product after another while Pixar was producing back-to-back movie hits. Apple was on its way to becoming the most valuable company in the world. After more than a decade of disappointment and failure, Steve Jobs was living out one of the greatest comebacks in American business history.

"If you give some-one a hammer, they can build a house or tear it down. Photoshop is just a better hammer."

—Russell Brown, Adobe Systems creative director and Photoshop evangelist, addressing criticism from traditional photographers that digital technology was destroying photography

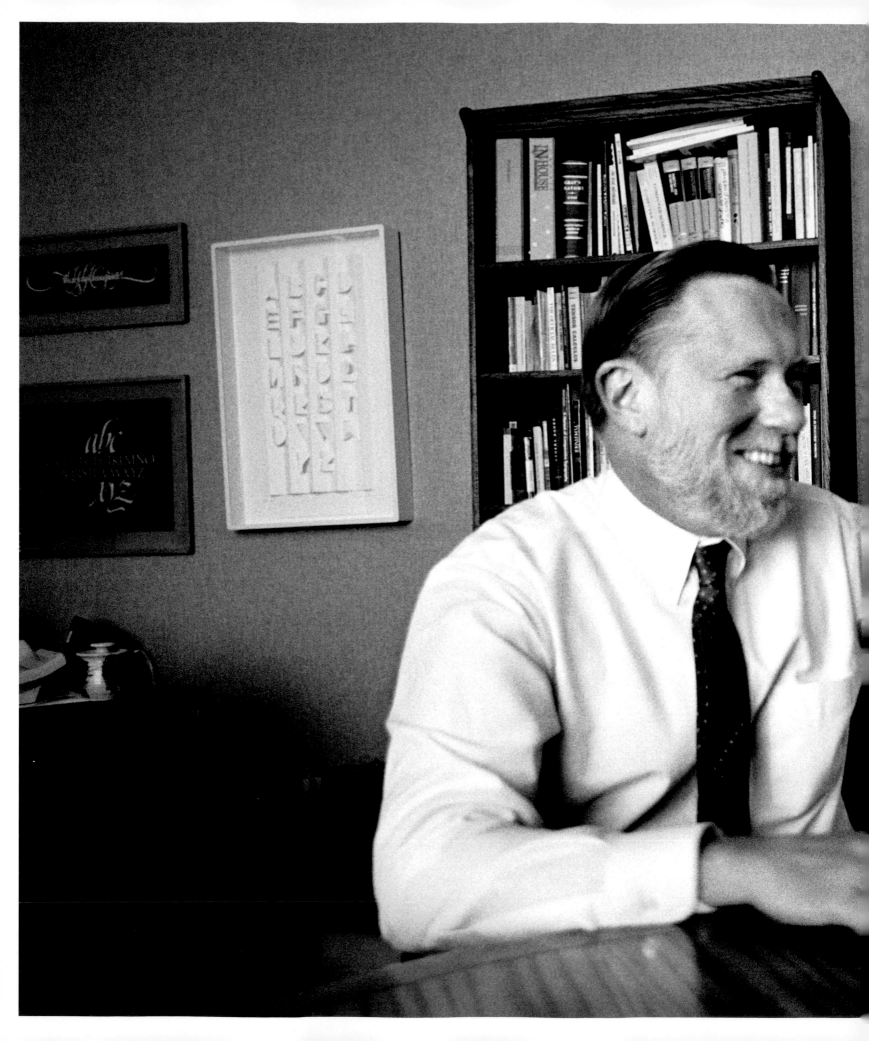

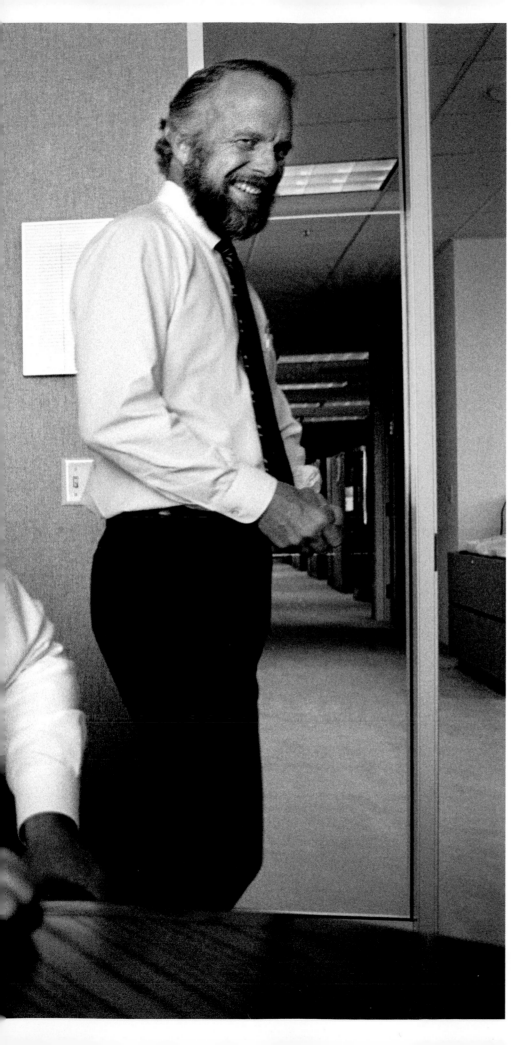

The Founders of Adobe Systems Preparing to Release Photoshop.
Mountain View, California, 1988.

John Warnock and Chuck Geschke (*seated at left*) confidently ready the launch of Photoshop, a landmark program that would utterly transform photography and the graphic arts. This followed their first breakthrough software called PostScript, completed after twenty thousand man-hours of coding, which allowed personal computers to talk to printers. This seemingly small function was incredibly difficult to achieve and represented the biggest advance in printing since Gutenberg invented movable type in 1436. The duo left Xerox PARC (Palo Alto Research Center) after their brilliant ideas were ignored and founded Adobe in 1982 with $2 million. They read exactly one business book prior to starting and intended to sell a personal desktop computer with a printer. They did not initially envision revolutionizing the desktop publishing industry with fonts or design software. A few months after they opened for business, Steve Jobs showed up (1982, riding high in his first stint as CEO at Apple) and demanded to buy the company. His then in-development Macintosh was going to ship with a laser printer, but his team could not write the requisite software. Steve pressed them to sell and come work for him. As Chuck told the story, they refused, and Steve responded, "You guys are idiots!" They called their investors, who urged them to work something out with Steve. They agreed to sell him shares worth 19 percent of the company, for which Steve paid a five-times multiple of their company's valuation at the time, plus a five-year license fee for PostScript, in advance. This made Adobe the first company in the history of Silicon Valley to become profitable in its first year.

Russell Brown in Costume.
Mountain View, California, 1989.

In a public defense of the early
Photoshop, Adobe Systems creative
director Russell Brown pointedly
said that software is just a simple
tool, like a hammer. You can use it to
build a house or tear one down. Many
photographers and graphic design-
ers resisted digital technology and
heavily criticized Photoshop. Perhaps
more than anyone else, Russell Brown
deserves credit for the dominance of
Photoshop by winning over the cre-
ative community with his Photoshop
classes and lectures where influential
photographers, graphic designers, and
artists were invited to come learn the
software.

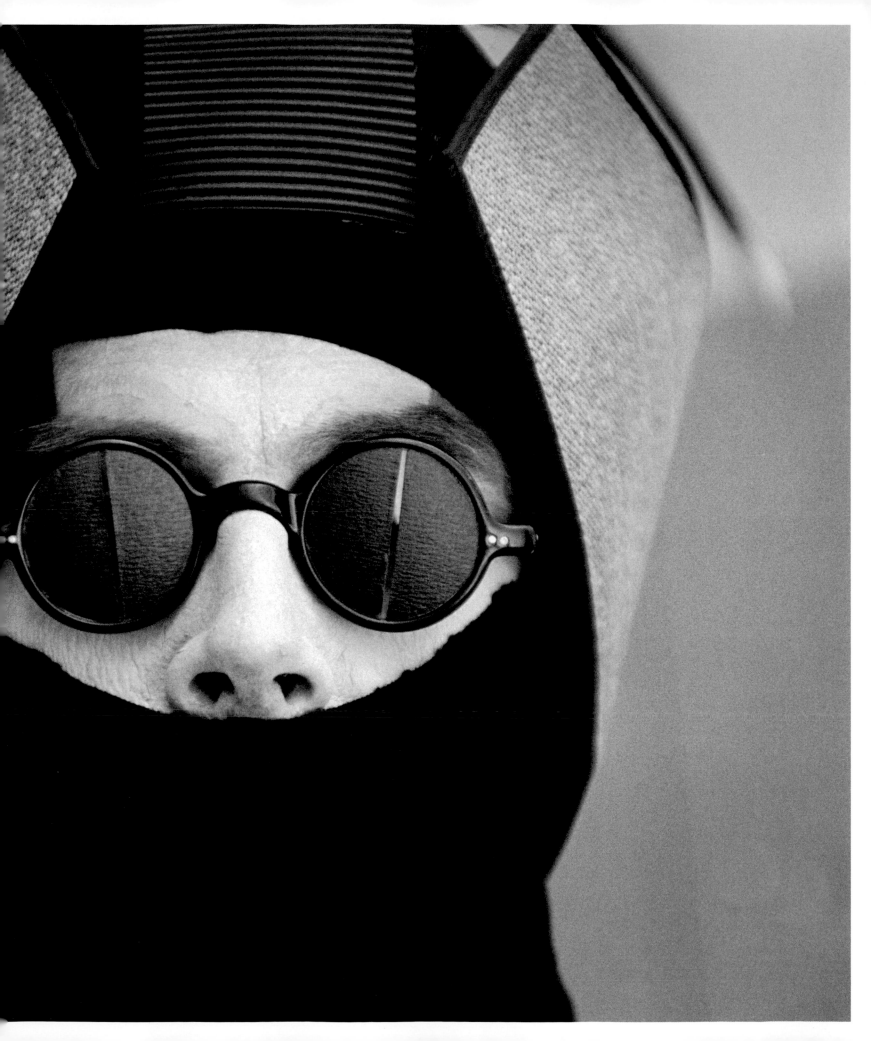

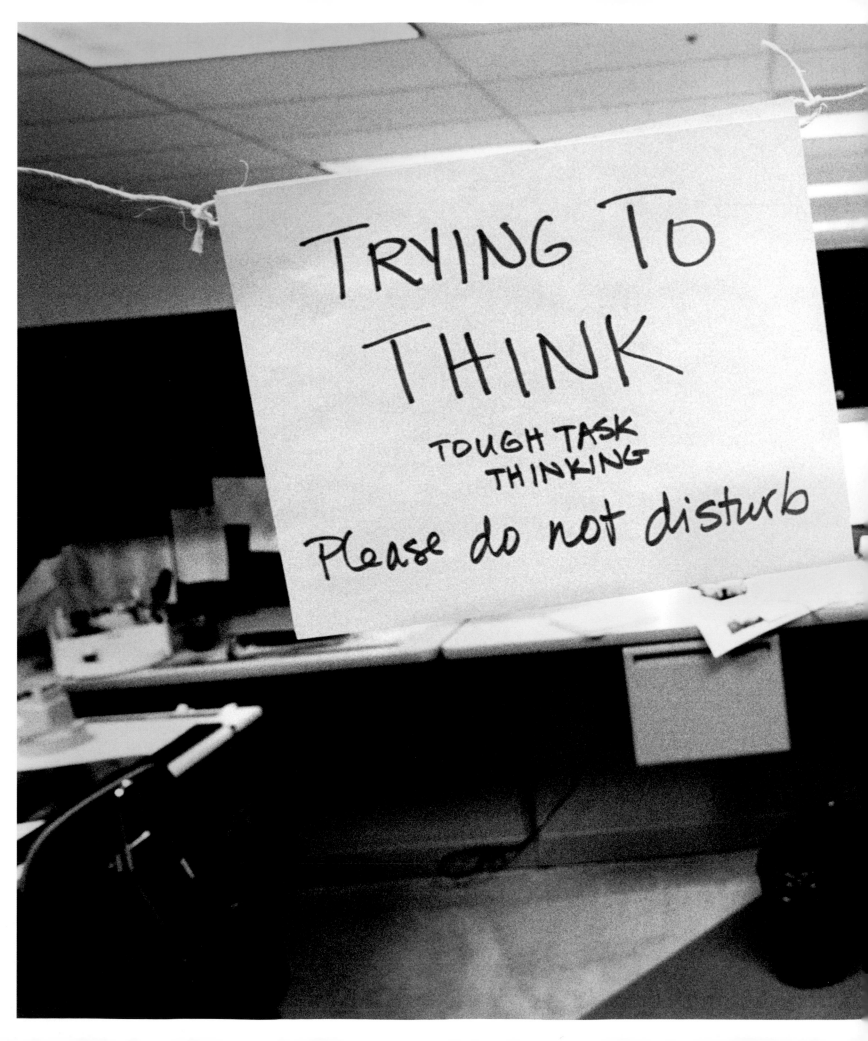

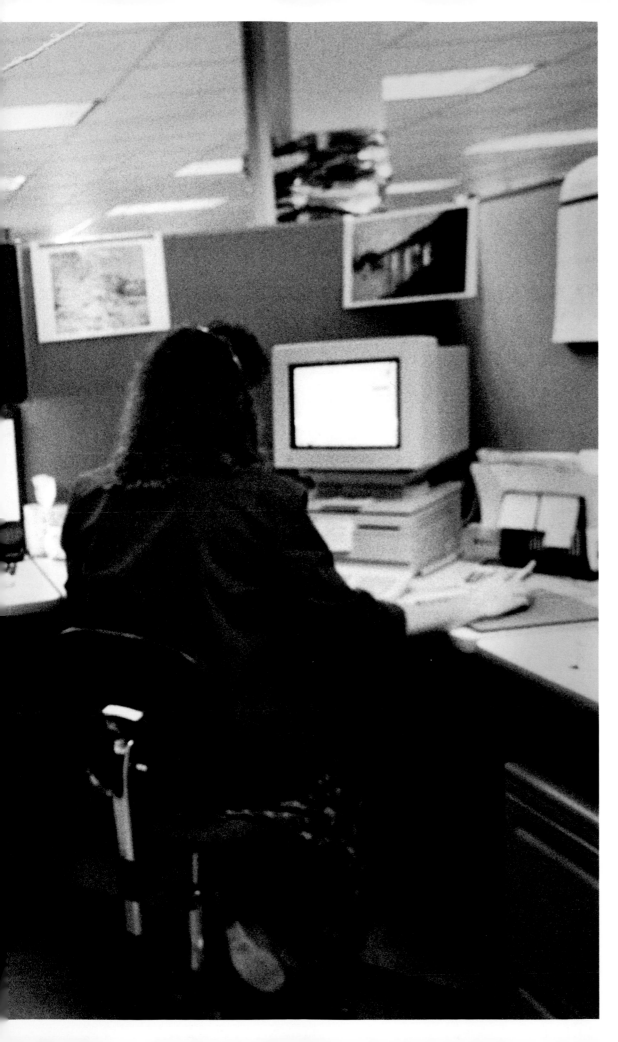

Universal Language.
Mountain View, California, 1988.

A team of Adobe type designers
working on creating PostScript
versions of Japanese-language
character sets. Adobe added
kanji printer products in 1988,
making PostScript the first
truly international standard for
computer printing. Its underlying
algorithms describing the letter-
forms of any language became a
new global idiom.

Thinking Difficult Thoughts.
Mountain View, California, 1988.

Much of the arduous work
of technology development
involves solitary concentration
and happens inside people's
heads. It was not only tough to
think, but difficult to get away
from the constant interruptions
of daily work life that we now
call multitasking.

Oasis in the Valley.

Mountain View, California, 1989.

Compared to the emotional roller coaster at NeXT and other start-ups, Adobe had a serene atmosphere that was also conducive to creativity. Their mature management team was quietly building a global brand. Here, graphic designer Luanne Seymour Cohen pauses between meetings with engineers.

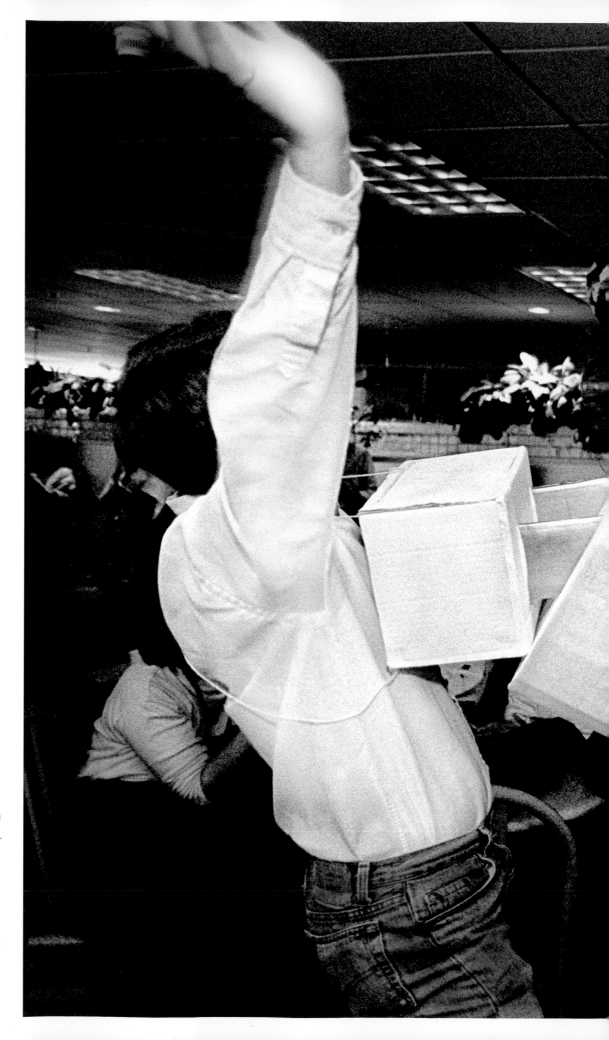

Geek Sex.

Mountain View, California, 1991.

Real-life boyfriend and girlfriend act out a rudimentary electrical metaphor at an Adobe Halloween party. Technology workers were notoriously socially inept and often shy, especially male engineers. Fantasy games and role-playing were popular, and any opportunity to dress in costumes was welcomed. This couple repeated the ritual all over the company to the delight of fellow workers.

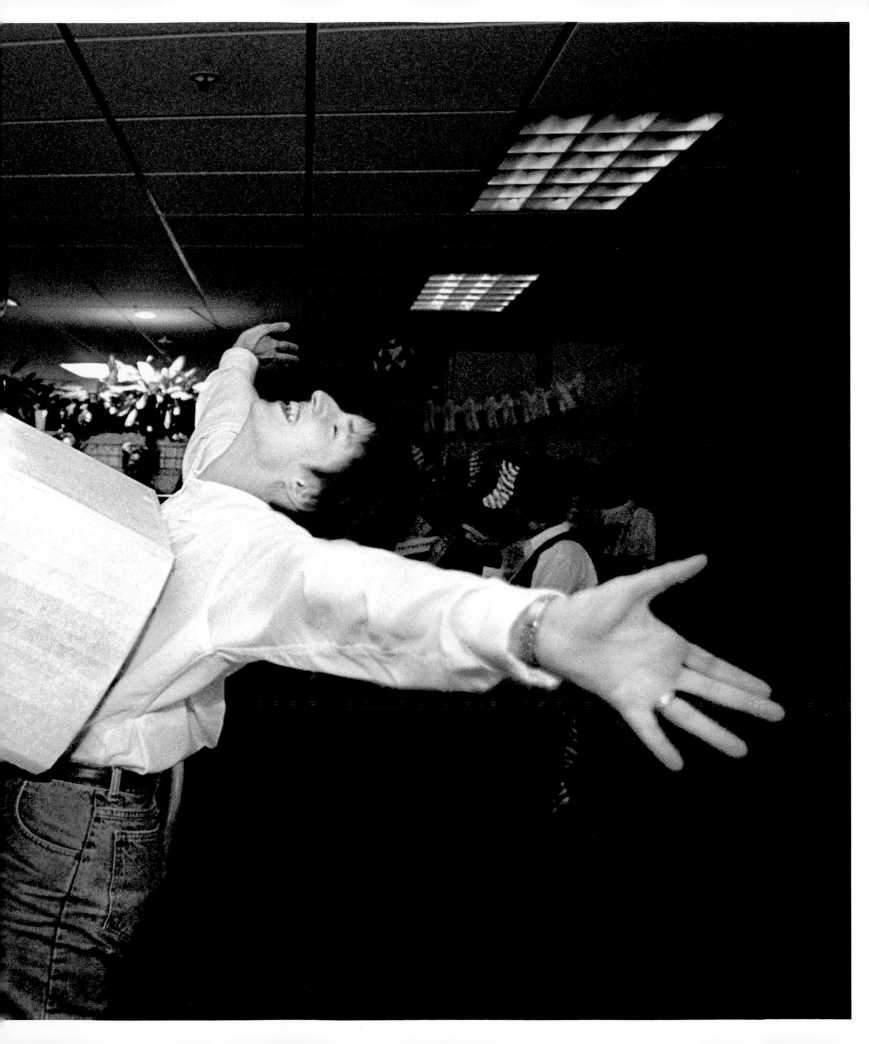

The Soul's Joy Lies in the Doing.
Silicon Valley, California.

As Shelley and Shakespeare both suggested, the journey can be its own reward. Although 90 percent of life in Silicon Valley was an unrelenting flow of "doing" with lots of struggle, failure, complications, and pressure, rare but intensely sweet moments of release occurred as well. The work had purpose, so people had a confident optimism to see themselves through. There seemed no greater high than solving a problem or simply blowing off steam after months of intense effort. *Clockwise from top left:* Sun Microsystems, Mountain View, California, 1995; Adobe Systems, Mountain View, California, 1992; Keith Yamashita, Apple Computer, Chicago, Illinois, 1992; Apple Computer, Singapore, 1994; Adobe, Mountain View, California, 1992; Tom Rielly (*right*), Farallon Computing, 1989; Adobe, San Francisco, California, 1988; Apple Computer, Boston, Massachusetts, 1993.

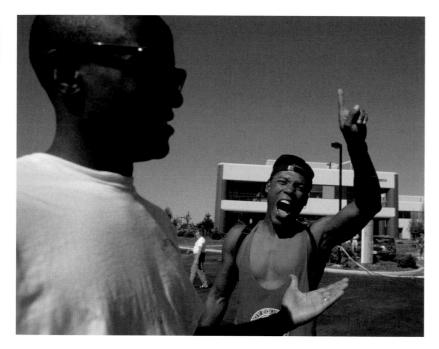

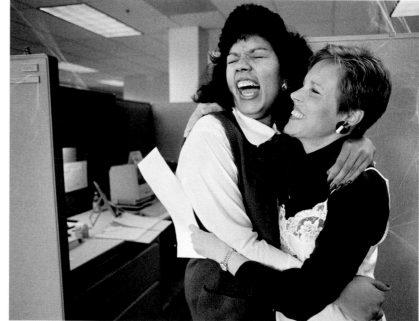

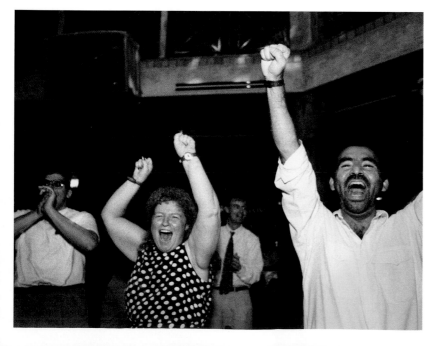

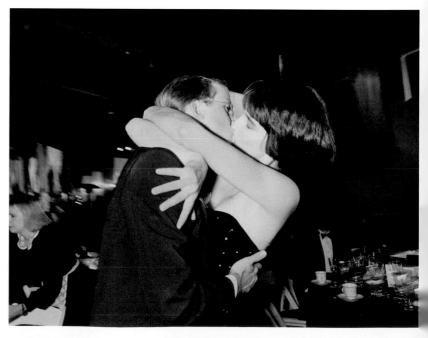

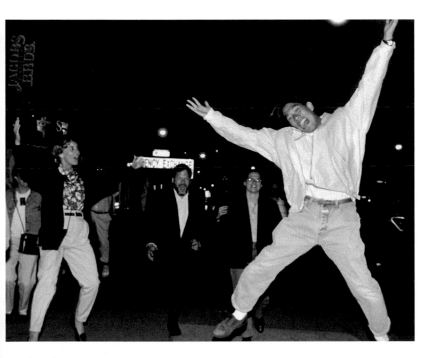

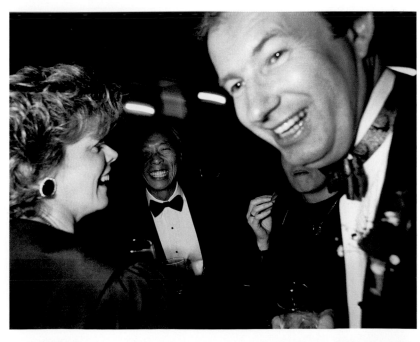

On Vacation.

Mountain View, California, 1994.

What appears to be an amusing scene carries a subtle subtext about the pressures to keep working. As Silicon Valley companies evolved from kids in garages to global technology behemoths, they began to adopt standard corporate practices such as granting health insurance and paid vacations. Adobe Systems offered everything employees could want, it seemed. Still, the hours were long and competition fierce, so vacations were often deferred or delayed. When people did go ahead and actually take the vacation days they'd earned, they might return to find their office had been "redecorated."

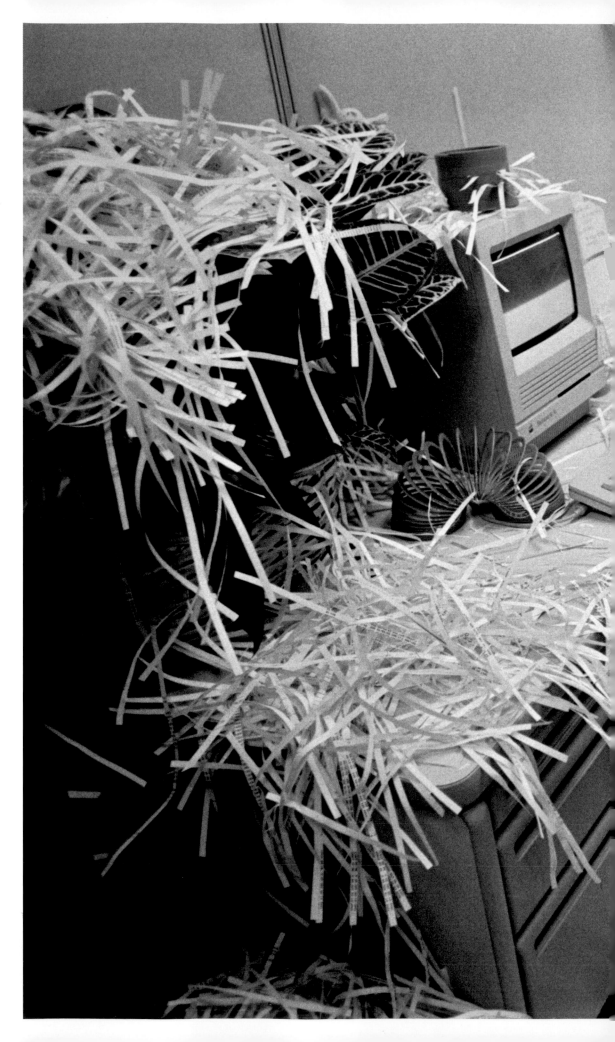

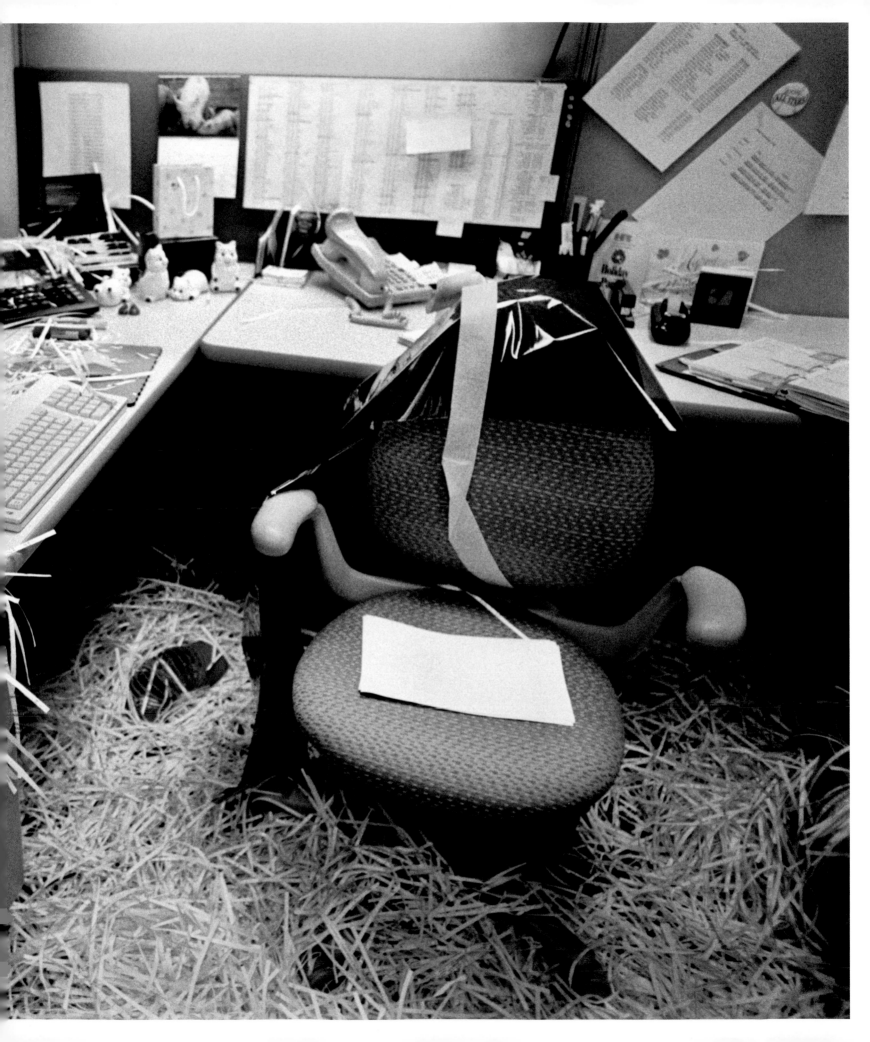

**The Painter David Hockney
Rests during the First
Photoshop Invitational.**
Mountain View, California, 1990.

As digital technology grew more
powerful, Silicon Valley became an
unexpected crossroads of culture.
Artists arrived from all over the
world, eager to experiment and hang
out at happenings such as the TED
conference, creating a freeway-and-
office-park version of what Paris in
the twenties must have felt like. Pro-
ducer Quincy Jones and musicians
Peter Gabriel and Herbie Hancock
were early adopters. Graham Nash
was so taken he started his own
fine-art digital-printing business. Tom
Wolfe had been out to write about
Bob Noyce, the coinventor of the
integrated circuit, and lots of writ-
ers followed, including Steve Jobs's
half sister Mona Simpson. George
Lucas was a pioneer in digital film,
as was Francis Ford Coppola. The
cultural ground was shifting, with the
avant-garde gathering to push new
digital ideas into the zeitgeist. Here,
painter David Hockney, holding one
of his beloved dachshunds, attends
Russell Brown's first Adobe Photo-
shop Invitational, where he learned
how to use the first-release version
of Photoshop, happily smoking in the
computer room and playing with his
dogs on breaks.

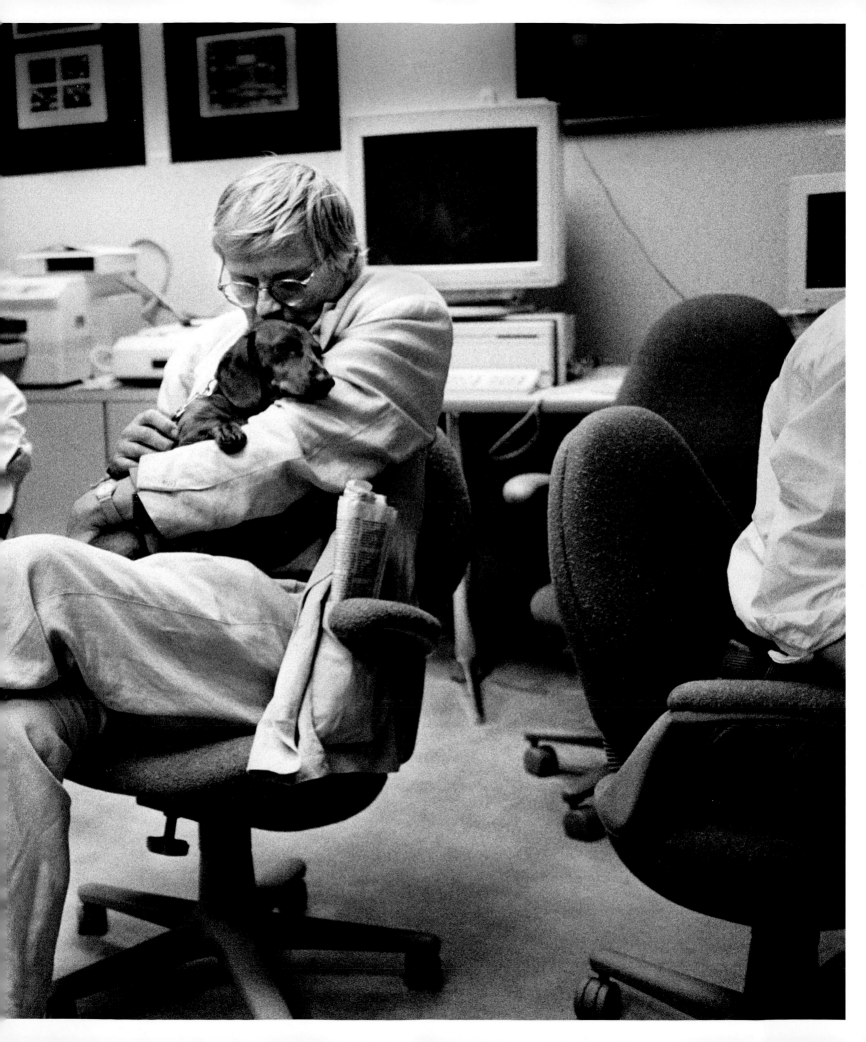

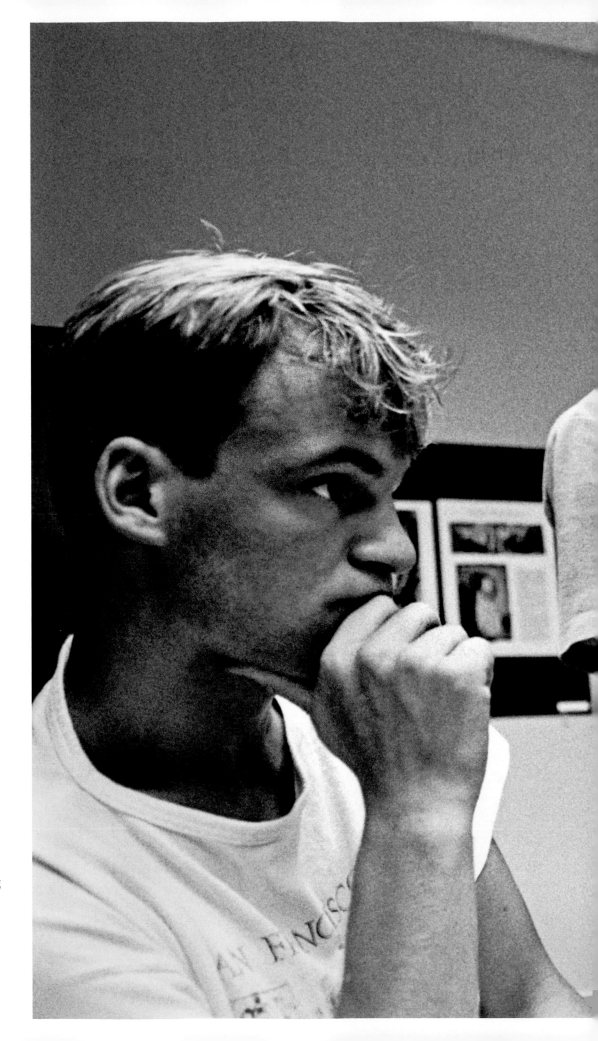

A Master of Analog Critiques a Digital Salon.
Mountain View, California, 1990.

At the first Adobe Photoshop Invitational, the (unidentified) assistant to painter David Hockney, graphic designer Min Wang (*center*), and Adobe Creative director and founder of the invitational, Russell Brown (*right*), listened to Hockney critiquing his own work and the work created by other invitational attendees with the brand-new Adobe Photoshop software.

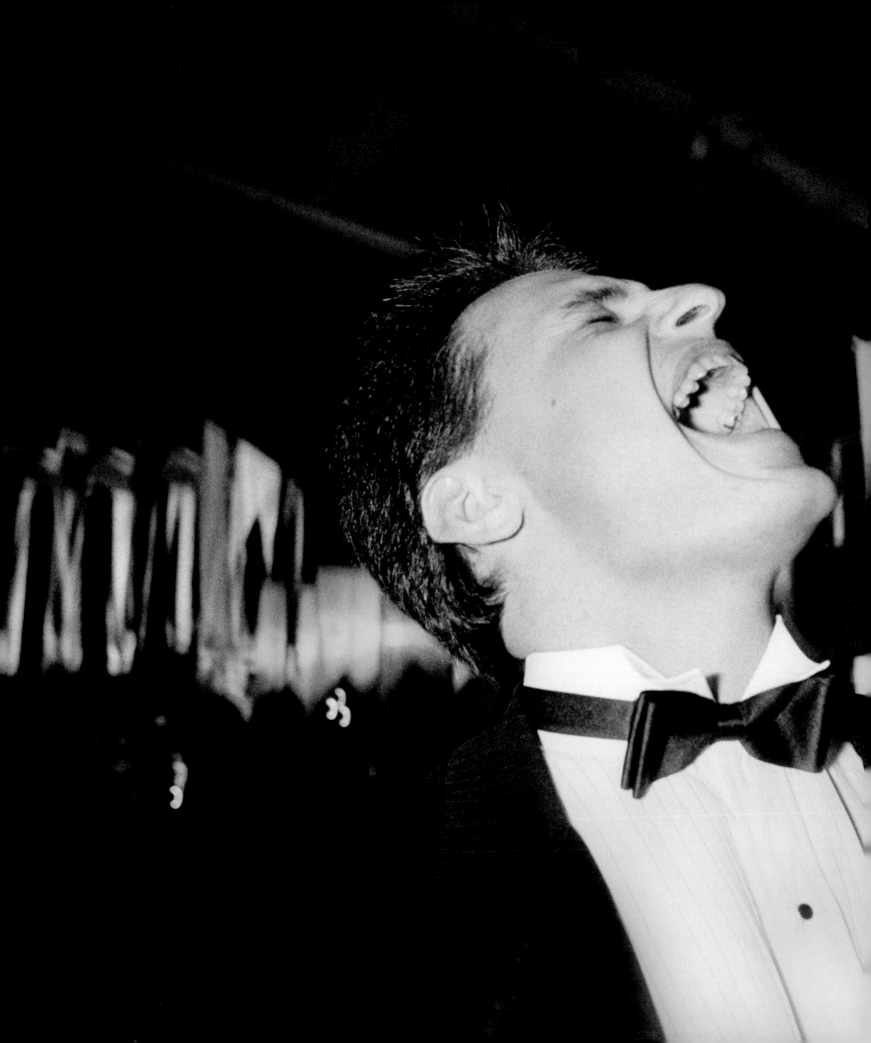

Howl.

San Francisco, California, 1988.

An Adobe Systems employee screams with joyful release during a toast to their spectacular year. Their year-end party was staged in a massive building on a pier in San Francisco and reportedly cost a million dollars. As Silicon Valley growth and success soared through the 1980s, holiday parties came to rival Las Vegas stage productions.

"At the time I left, Apple was the number-one-selling personal computer in the world. We were, by the way, the most profitable computer company in the world,

because IBM was losing money, HP was making almost no money from computers, Dell barely existed at that point, Compaq was failing."

—John Sculley, former Apple Computer CEO, who grew the company after Steve Jobs left from $800 million to $8 billion in yearly revenue before he left in 1993

John Sculley Masters His Shyness to Meet the Press.

Fremont, California, 1990.

At the factory in Fremont, Apple CEO John Sculley charms the press. He overcame severe shyness and a stutter to eventually become CEO of Pepsi and was then convinced by Steve Jobs to join Apple in 1983. After forcing Steve out, John grew Apple from $800 million to $8 billion a year in revenue. Despite this significant achievement, he was often dismissed in the Valley as the man who fired Steve and, unfairly, as a technology lightweight without a vision. In fact, he worked hard to find and encourage the best ideas inside the company, such as the Knowledge Navigator, which in 1987 anticipated many aspects of today's internet, software agents, and the potential of tablet and voice-command technology. At the height of his power, in February 1993, he was seated next to First Lady Hillary Clinton at President Bill Clinton's first State of the Union address. John knew then that despite outward appearances, Apple was tilting toward chaos, unable to rewrite its operating system and innovate against the threat of Microsoft. Once tech companies have successful cash cows such as the Mac, it becomes inherently more difficult to innovate because it often means killing the cash cow. Apple's Macintosh was profitable, but its market share was dropping fast due to the growth of Windows. Meanwhile a small team at Apple were exploring a handheld computing device. John's solution to provide a new revenue stream alongside the Macintosh was to green-light this rebel unit to develop the world's first personal digital assistant, or PDA. The Newton, as it was called, would be a new type of product for a market that did not yet exist. It was an ambitious gamble.

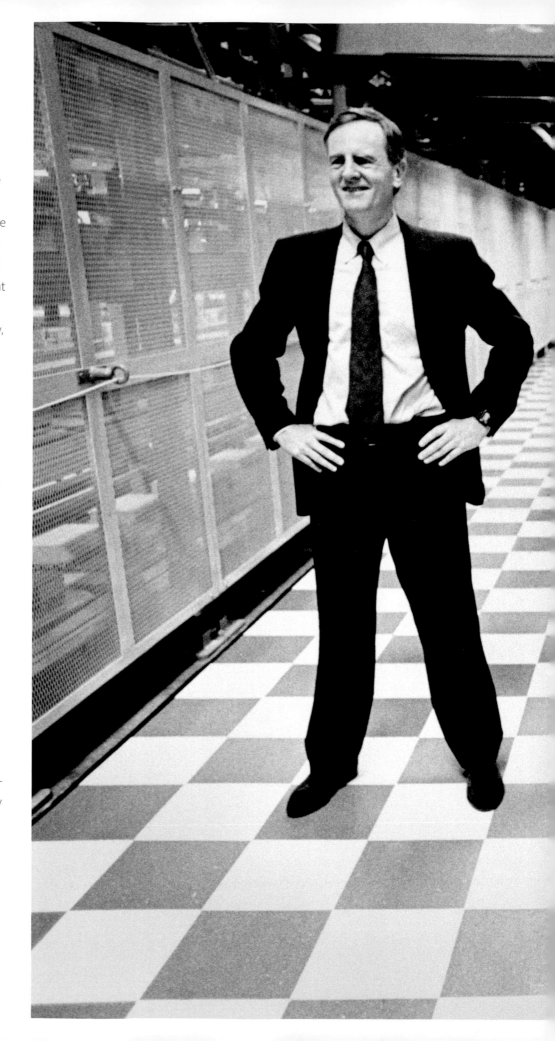

Steve Capps Playing the Jaminator.
San Carlos, California, 1993.

Steve Capps, a modest, unsung hero in the Valley, is codesigner of the Macintosh Finder and helped develop much of the graphical user interface upon which all interface innovation over the past few decades is based. In this image, he's playing the Jaminator, a digital guitar he invented that lets you play your favorite guitar solos to various hit rock songs, while working at home on the Newton software. Working twenty-hour days was what led Steve to start working from home, where I would sometimes arrive to find him asleep on a mattress on his front porch in the blazing morning sun. He said he wanted the Newton to be so intuitive that his mother could use it. Capps would later quit Apple to work for its sworn "frenemy," Microsoft.

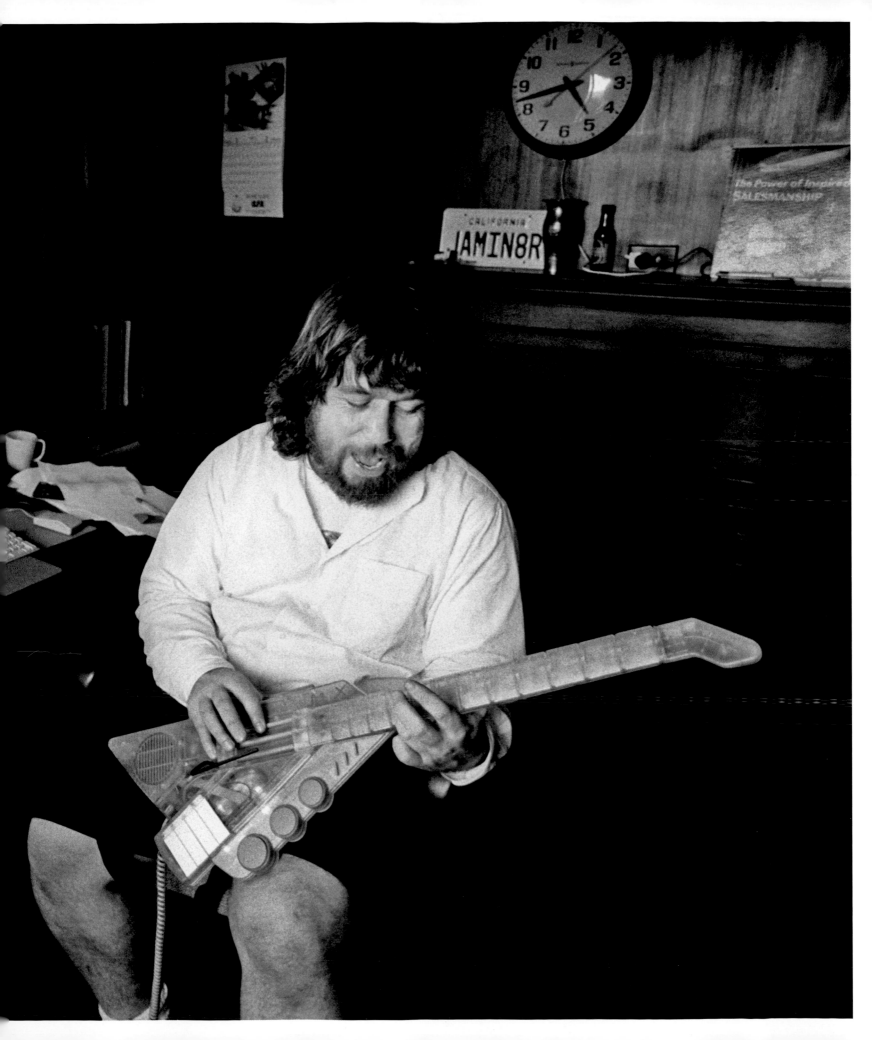

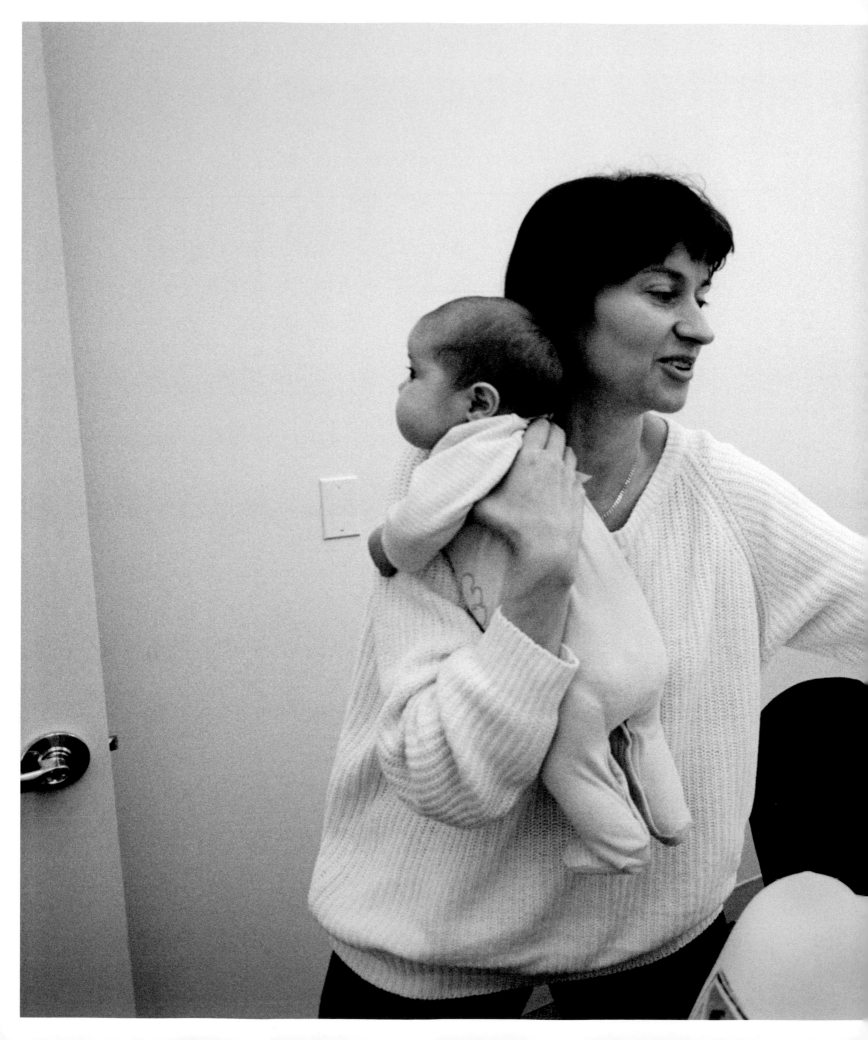

The Newton War Room at Apple Computer.
Cupertino, California, 1993.

Apple programmer Sarah Clark kept her newborn baby with her at work, almost never leaving the building for two years as the team rushed to finish the software. She pulled curtains over her office so colleagues knew when it was naptime or if she was breast-feeding. Her dedication was typical of Apple employees, and management was generally grateful. Flexible hours and other worker-friendly modifications were adopted, and John Sculley showed leadership by appointing women to positions of power, unusual in Silicon Valley at that time. What's not often considered is that whoever writes the code determines how the machine will behave and interact with the user. What if someone other than a twentysomething white-male geek wrote the code? A different worldview would likely change the priorities of the code writer, and that would likely change the nature of the technology that is so profoundly shaping our behavior and culture.

Woz.

San Francisco, California, 1991.

Apple Computer cofounder Steve Wozniak (*middle*) and John Sculley, CEO (*right*), looking at an early Nintendo Game Boy before taking the stage at an Apple product announcement. Many at Apple were intrigued to learn that contrary to Wall Street's hyper-short-term thinking and the typical American business plan, Nintendo had conceived a hundred-year business model for itself.

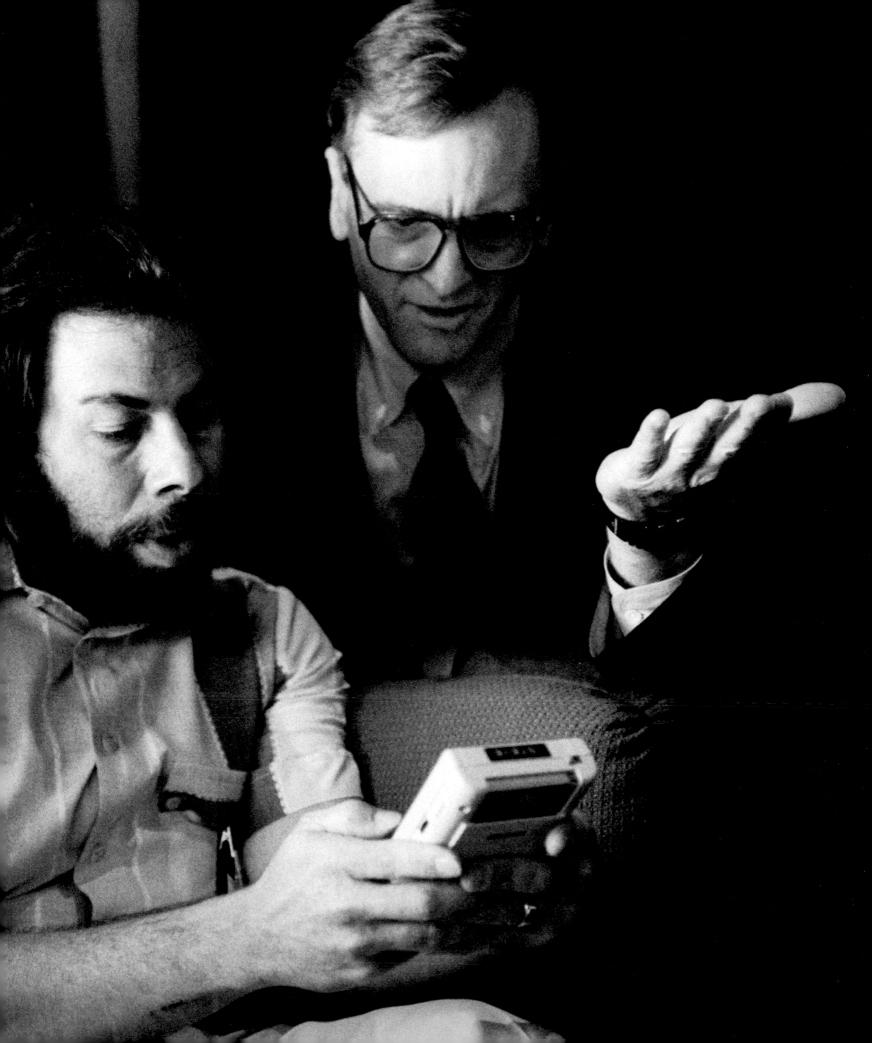

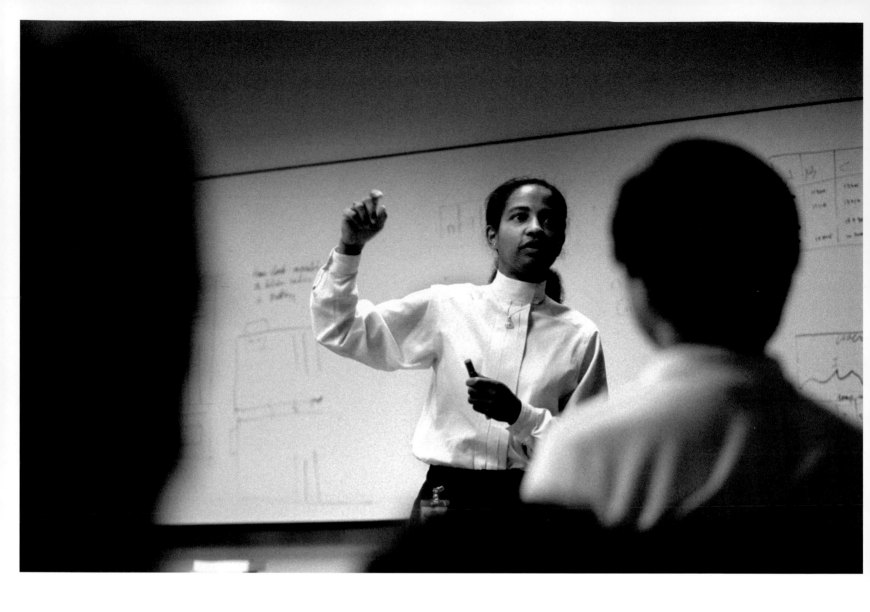

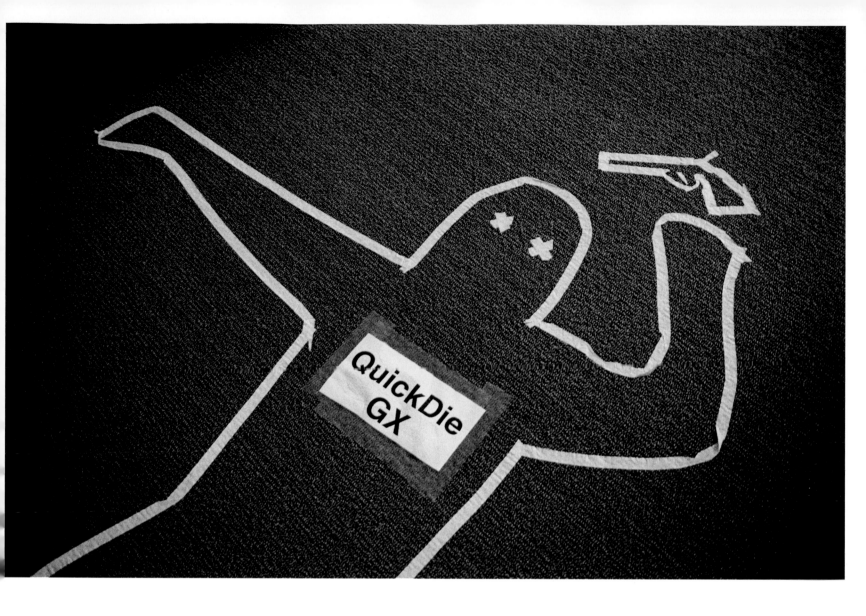

A New Tool for New Thinking.
Cupertino, California, 1992.

Donna Auguste, a senior engineering manager at Apple Computer, coordinated the development of the Newton personal digital assistant, working as part of legendary computer scientist and Apple VP Larry Tesler's team. She received her undergraduate degree in electrical engineering and computer science from UC Berkeley, and her master's from Carnegie Mellon before working her way up through Silicon Valley and being hired by John Sculley. She came with a patient, supportive management style that was a balm to a group working in almost constant crisis. It's tough enough to bring out a new product with one new technology. Yet Steve Jobs attempted to combine and develop *multiple* new and existing technologies into one new product at NeXT, and not far away the Apple Newton team was striving to do the same thing. Aside from developing new hardware and software, they also had to create a product identity and brand that would cross over several product categories. Apple at that time made only personal computers; the team now needed to learn everything about the consumer electronics market in which the Newton would be sold.

A Cry for Help at Apple Tech Support.
Austin, Texas, 1996.

Although the Macintosh was designed to be easy to use, as it evolved it became more complex and unwieldy. Users were frustrated and angry and took it out on tech support employees. At the Apple center in Austin, one employee vented his frustration at Apple's own buggy QuickDraw software with a graphic floor display.

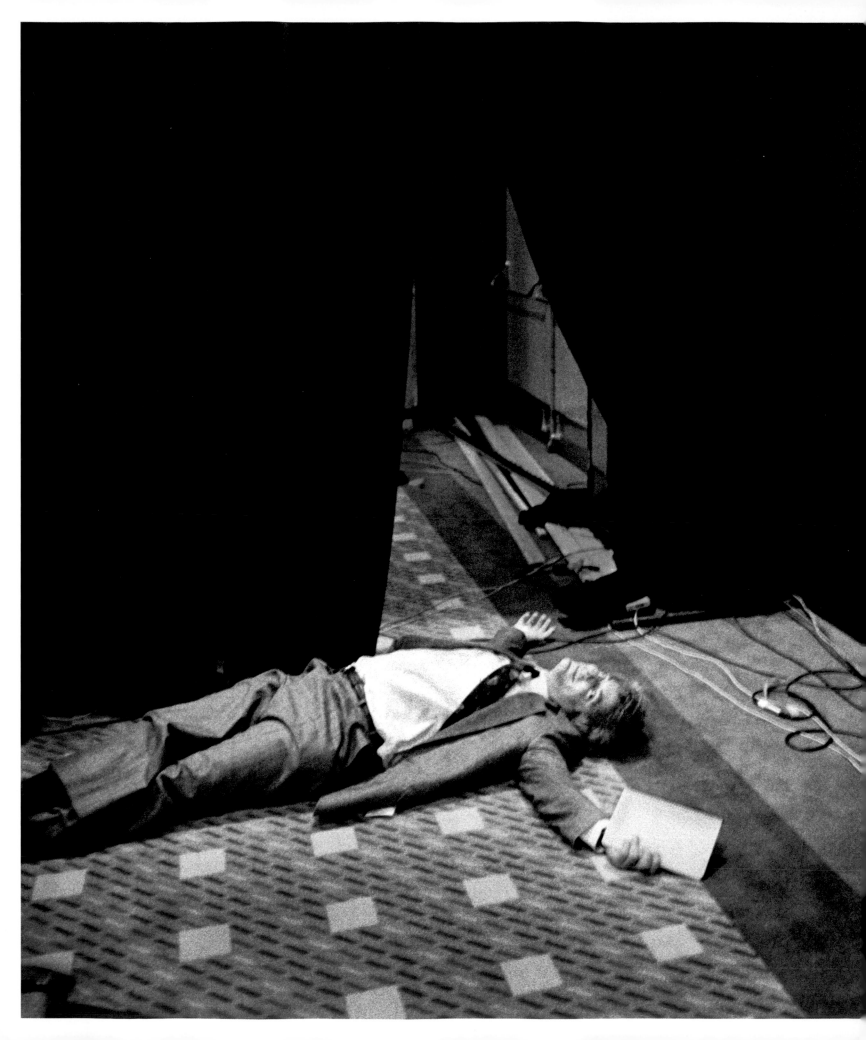

Preparations for the Demonstration Are Not Going Well.

Las Vegas, Nevada, 1993.

While preparing a demonstration of the Newton personal digital assistant for the national press in Las Vegas, the device crashed, causing event organizer Michael Witlin to hit the floor in exasperation and PR specialist Tricia Chan to call Steve Capps for help. While the formal demonstration went ahead for the press without the actual working product, Tricia and Steve gave a successful private demonstration in an adjacent room to reporters from the *Wall Street Journal* and the *New York Times*, whom they knew would be more forgiving if the demo failed again. The two papers published favorable stories, as did most of the other press, as the overall reaction was positive despite the crashed software. The Newton promised to organize names, addresses, calendars, and notes and would also provide infrared beaming, fax, and e-mail capability years ahead of any other device. It also used an advanced form of handwriting-recognition software based on natural gestures. Apple had worked on this recognition software for years, but could not solve the tricky challenge. Then, by chance, one night in 1987 in Moscow, in the final years of the Cold War, an Apple board member answered a frantic knock at his hotel door. A Russian engineer nervously handed him a disk and walked away. The disk contained the handwriting-recognition software Apple desperately needed and was quickly incorporated into the Newton. Even with this covert help, the recognition software would still need years of development, years Apple did not appear to have.

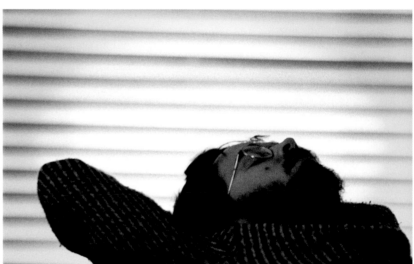

Sleep When You're Dead.

Silicon Valley, California.

While Silicon Valley offered many rewards, the pervasive expectation from the companies (and from colleagues) was that everyone would work until he or she dropped. It could get competitive. A manager at Apple often challenged people to work all night and then to run with him at 6:00 a.m. Then he ran meetings all day and went out with clients at night—in both a macho display and a lesson about what sheer willpower can accomplish. Today we know that sleep deprivation leads to significant increases in errors and a loss of productivity. *Clockwise from top left:* Martin Gannholm, Apple Computer, San Carlos, California, 1993; Burt Cummings, Apple Computer, Las Vegas, Nevada, 1992; Steve Capps, Apple Computer, Cupertino, California, 1991; Keith Yamashita, Apple Computer, Cupertino, California, 1991; Reese Jones, Farallon Computing, Berkeley, California, 1980; John Warnock, Adobe Systems, Mountain View, California, 1988; Michael Hawley, NeXT Computer, Santa Cruz, California, 1987; Brook Byers, Kleiner Perkins, Aspen, Colorado, 1995.

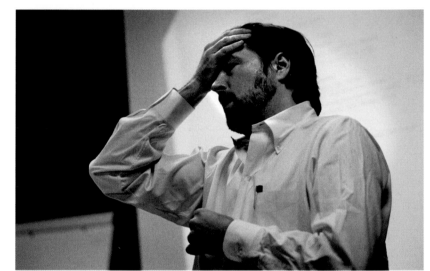

A Million Lines of Code.

Cupertino, California, 1992.

Programmer Peter Alley rests during the big push leading up to the announcement of the Apple Newton by John Sculley at the Consumer Electronics Show in Chicago. Only thirty programmers were writing a million lines of code with a deadline of one year, and nothing was quite working yet. Then John Sculley brought in Gaston Bastiaens from Phillips to rush the Newton to market under pressure from an impatient board. A decision was made to switch the Newton to a newer, faster chip, thus requiring all-new code. Management gave the team new marching orders: they had one more year to rewrite the entire million lines of code. A short time later, a young programmer named Ko Isono went home, loaded a pistol, and shot himself in the heart.

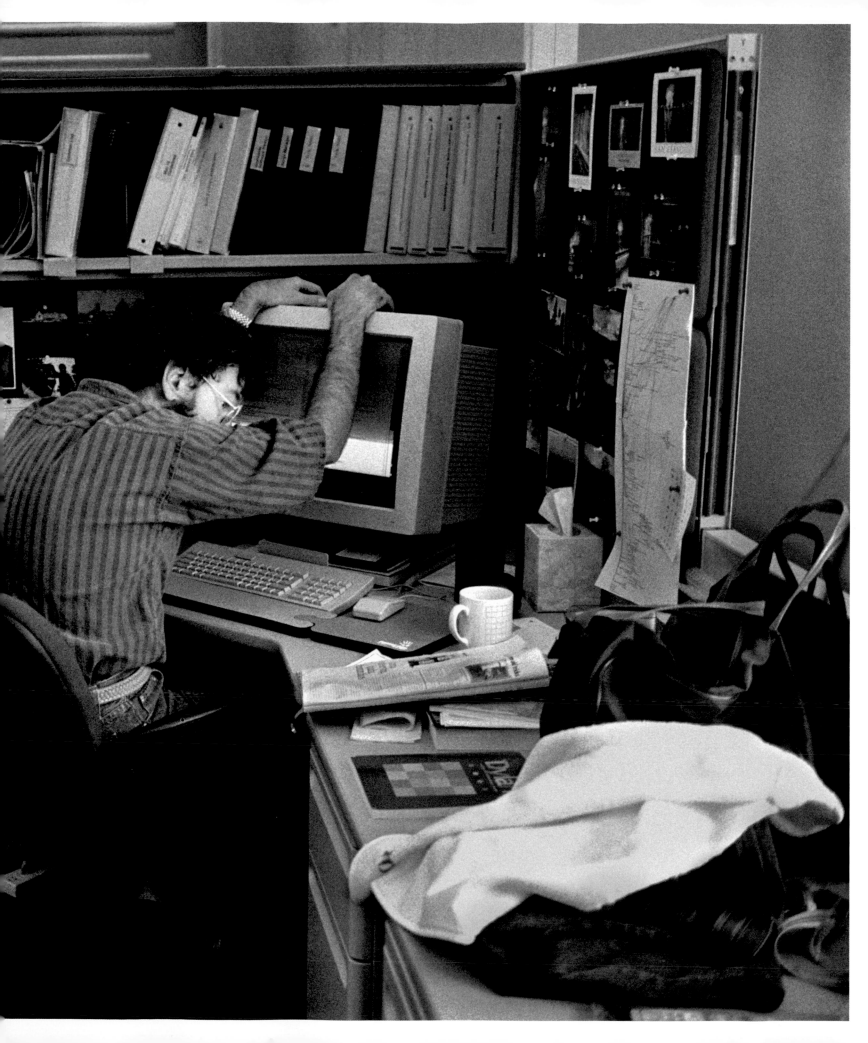

Braintank.

Cupertino, California, 1992.

Apple product marketing manager Michael Tchao leads his comrades in a subdued marketing meeting in the top-secret room they named the Braintank. Ko Isono's tragic death was devastating to the entire team but after a brief, bitter pause for reflection over the year-end holidays, the team came together in a forceful show of unity, determined to finish the job. Steve Capps, Tchao, and other team members worked straight through the holiday break, making significant technical progress that boosted morale. They also hid a dedication to Ko inside the Newton code only insiders could see.

An Infant at Apple.

Cupertino, California, 1993.

As the Newton team worked even more hours, including almost every weekend, they began to bring their families into the Apple offices, so they could see them during daylight hours.

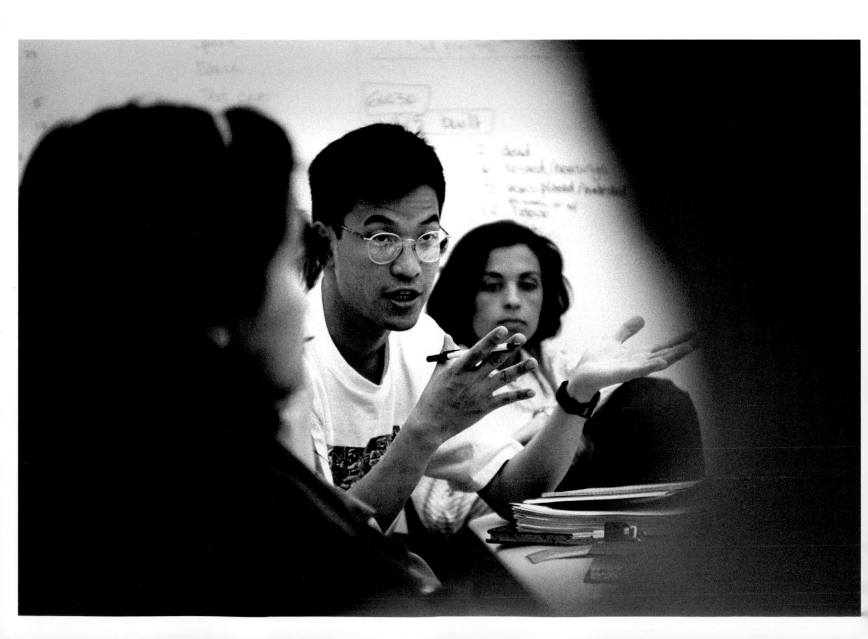

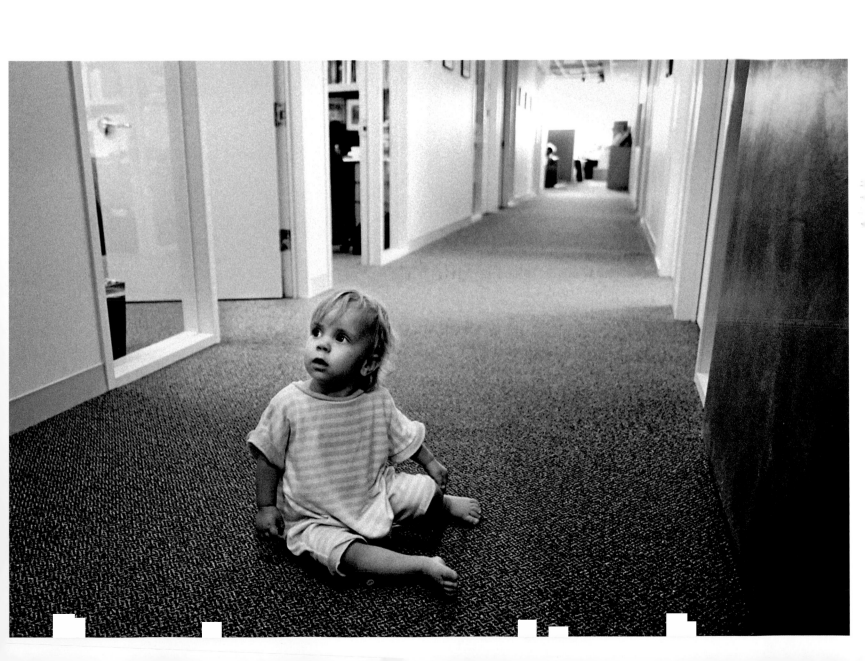

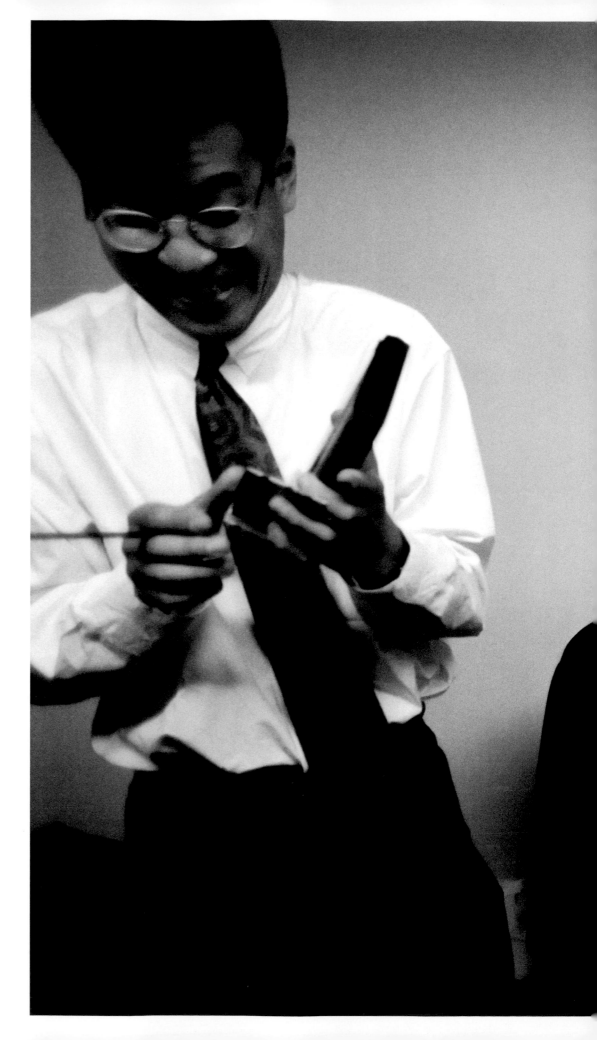

Imagine If You Will.

Hannover, Germany, 1993.

Backstage before a press briefing, Newton team members Michael Tchao, Nazila Alasti, and Susan Schuman discover that all eight of the prototype Newtons they brought to demonstrate are dead. They can hear the hundreds of German journalists, who've been quaffing free beer while waiting over an hour to see the promising new product, as they drunkenly chant, "New-ton, New-ton." Tchao soon took the stage and began his speech describing the nonfunctioning Newton prototype he was holding by pointing at the screen behind him and suggesting, "Imagine if you will . . ." Shortly after the Newton introduction, Tchao left Apple for a successful career at Nike. Years later Steve Jobs asked him to come back to Apple to run the marketing for the iPad and oversee its launch, closing the circle with the Newton and vindicating all the blood and sweat and effort.

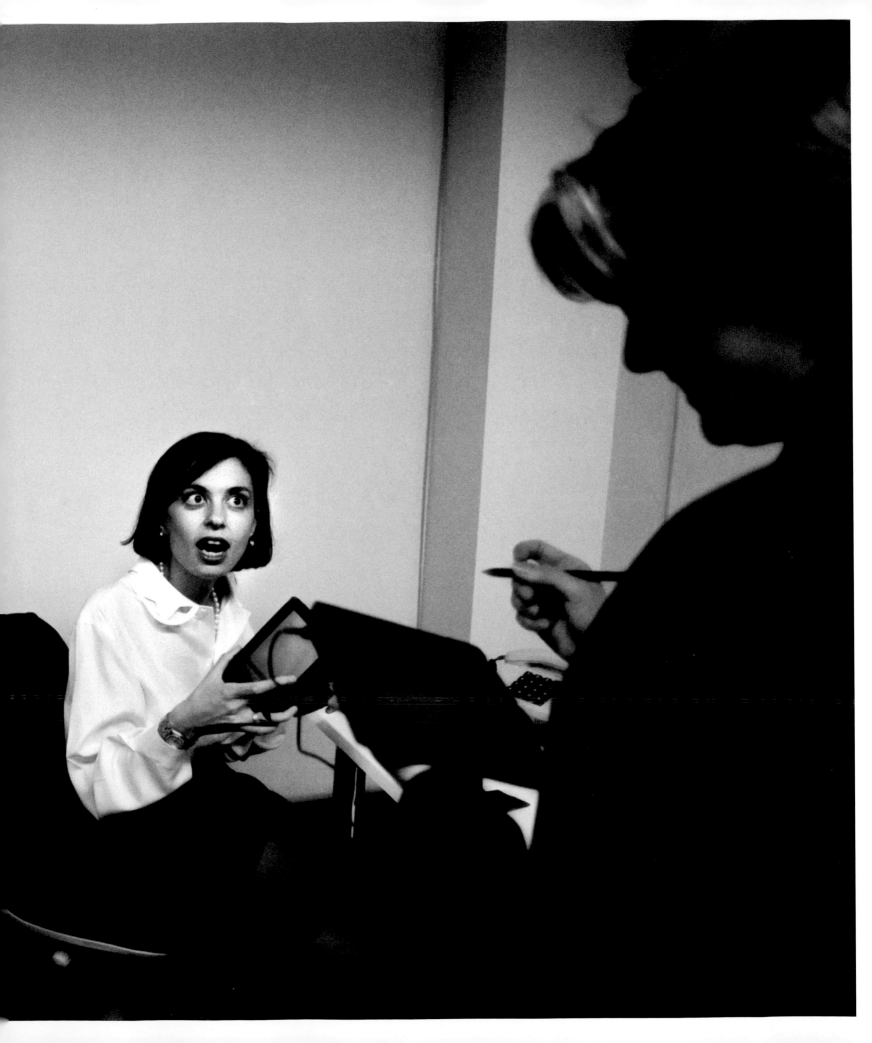

Calculated Risk.

Northern California, 1993.

Apple Newton software engineers defy orders (and gravity) to not risk their lives until the product was done. Their boss, software engineering manager Donna Auguste, was not amused, but understood their need to blow off steam after years of intense work.

Fanboys.

Boston, Massachusetts, 1993.

Apple diehards waited hours for doors to open upon the launch of the much-anticipated Newton. Apple had missed multiple deadlines with manufacturing partner Sharp, which had rushed four thousand units still running beta software to Boston in time for the launch. The Newton team was frantically gluing parts on by hand until the doors opened. In a bittersweet coda, John Sculley was there to preside over the event and support the Newton team, even though he'd already been forced to resign as CEO, ironically ousted in a boardroom coup, like Steve. His bid to bolster Apple with the groundbreaking Newton ultimately failed as sales never matched expectations. However, it did pave the way for the wildly successful PalmPilot. Later, Steve Jobs would kill the struggling Newton upon his return to Apple, but many of Newton's core ideas live on today in the iPhone and iPad.

"More jobs and wealth were created than at any time in human history."

—L. John Doerr, partner at Kleiner Perkins Caufield & Byers, reflecting on the digital revolution and its legacy

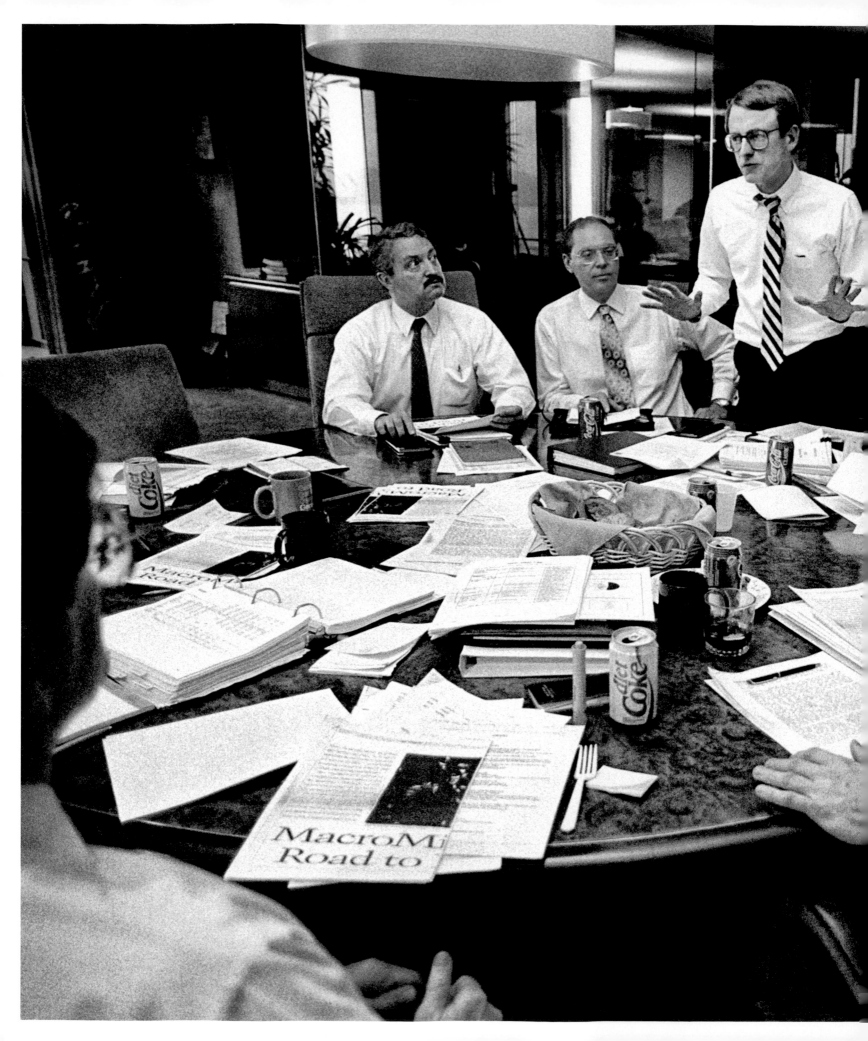

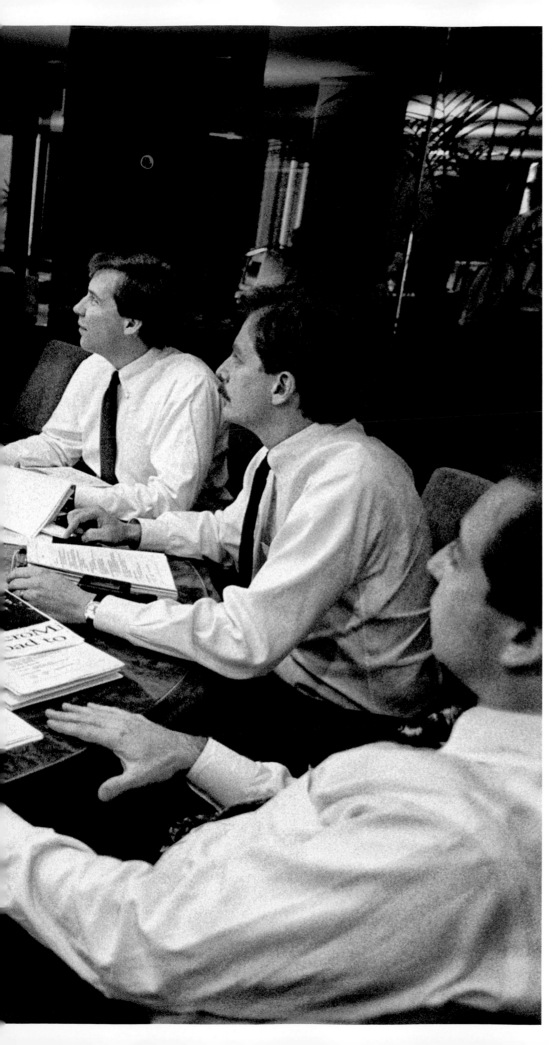

John Doerr and Partners Discuss the Future of the Internet.
Palo Alto, California, 1994.

John Doerr making a point during one of Kleiner Perkins Caufield & Byers's famous Monday-morning meetings where they reviewed potential companies they might invest in. Entrepreneurs would make their presentations quickly and hope for the best. Kleiner Perkins was already funding several early internet companies such as Macromedia, which introduced Flash, an important web development tool. They were about to help launch Netscape, which started a gold rush on dot-coms. Kleiner Perkins remains a premier venture capital firm with a storied legacy. Doerr and the company helped fund and found an astounding string of successful entrepreneurs and companies such as Lotus, Sun Microsystems, AOL, Intuit, @Home, Amazon.com, Netscape, Google, and Zynga, among many others. Doerr estimates ventures he backed created two hundred thousand jobs. Partners today include former vice president Al Gore, General Colin Powell, William Randolph Hearst III, and Bill Joy, cofounder of Sun Microsystems. Kleiner Perkins built a valuable *keiretsu* of growing companies that could share talent and resources, increasing their chances of success.

95

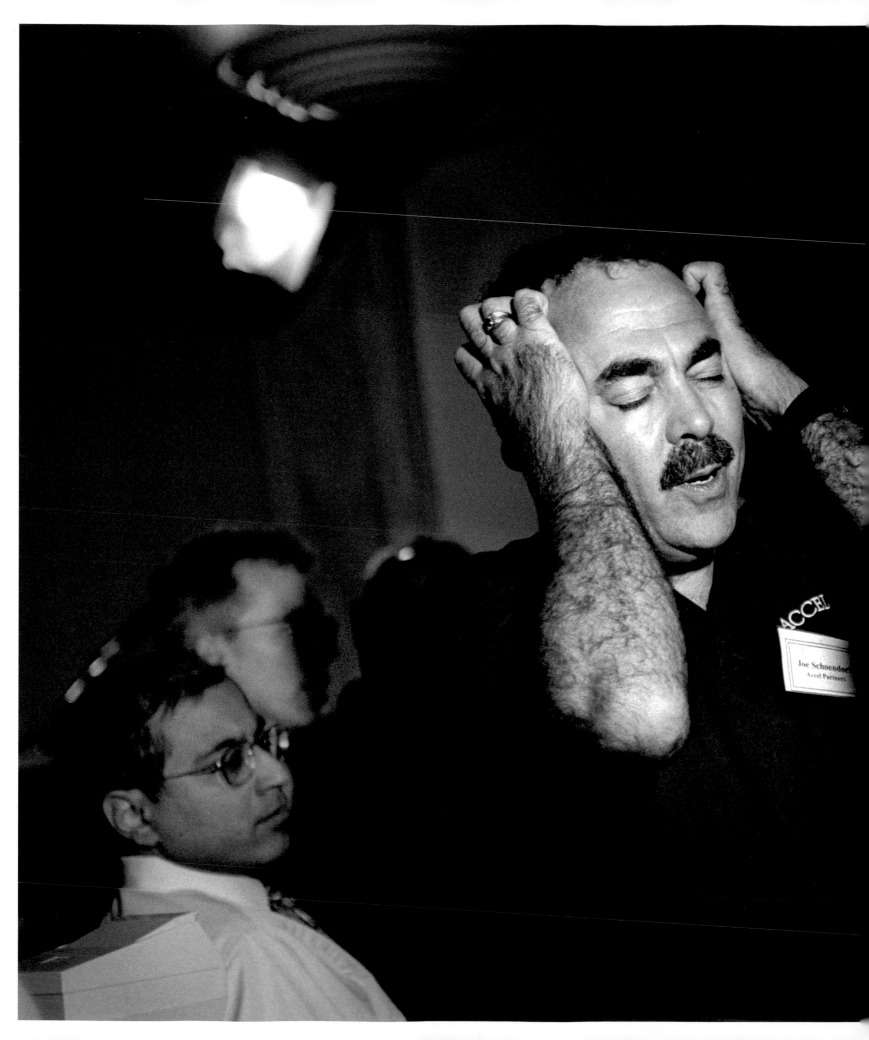

The Elevator Pitch.
Palo Alto, California, 1997.

At a special event for entrepreneurs hosted by the top venture capital firms, Joe Schoendorf, from Accel Partners, reacts to an entrepreneur's idea for a start-up.

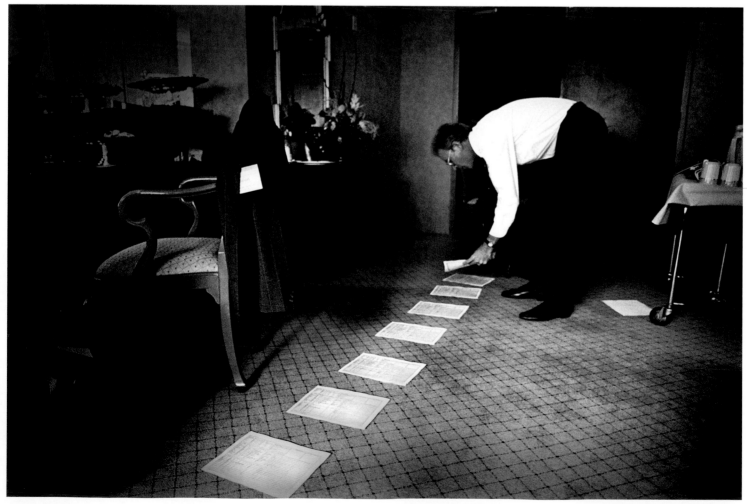

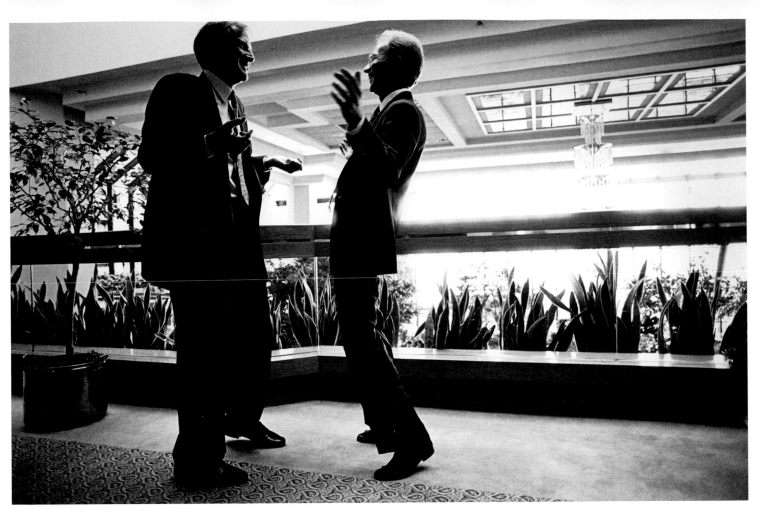

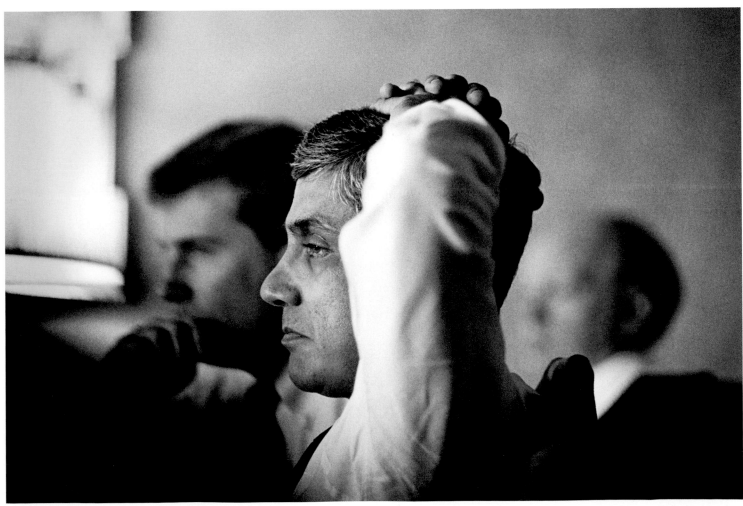

Previous Spread

Searching for Diamonds.

San Francisco, California, 1991.

During a computer industry
conference, the partners from
Kleiner Perkins break away
from the event to huddle in a
nearby hotel suite. They had to
sort through myriad opportuni-
ties and decide which start-ups
to throw their weight behind.
Clockwise from top left: Floyd
Kvamme and Regis McKenna;
Italian entrepreneur and CEO of
NetFRAME Enzo Torresi and Jim
Lally; Sun Microsystems co-
founder Vinod Khosla; Lally lays
out documents for review.

Can You Hear Me Now?

San Francisco, California, 1991.

Kleiner Perkins partners Brook
Byers (*left*) and John Doerr
(*right*) with Credit Suisse CEO
Frank Quattrone at a computer
industry conference, happy to be
using their brand-new Motorola
flip-style cell phones. Quattrone
helped bring dozens of tech
companies public, including
Cisco and Amazon.

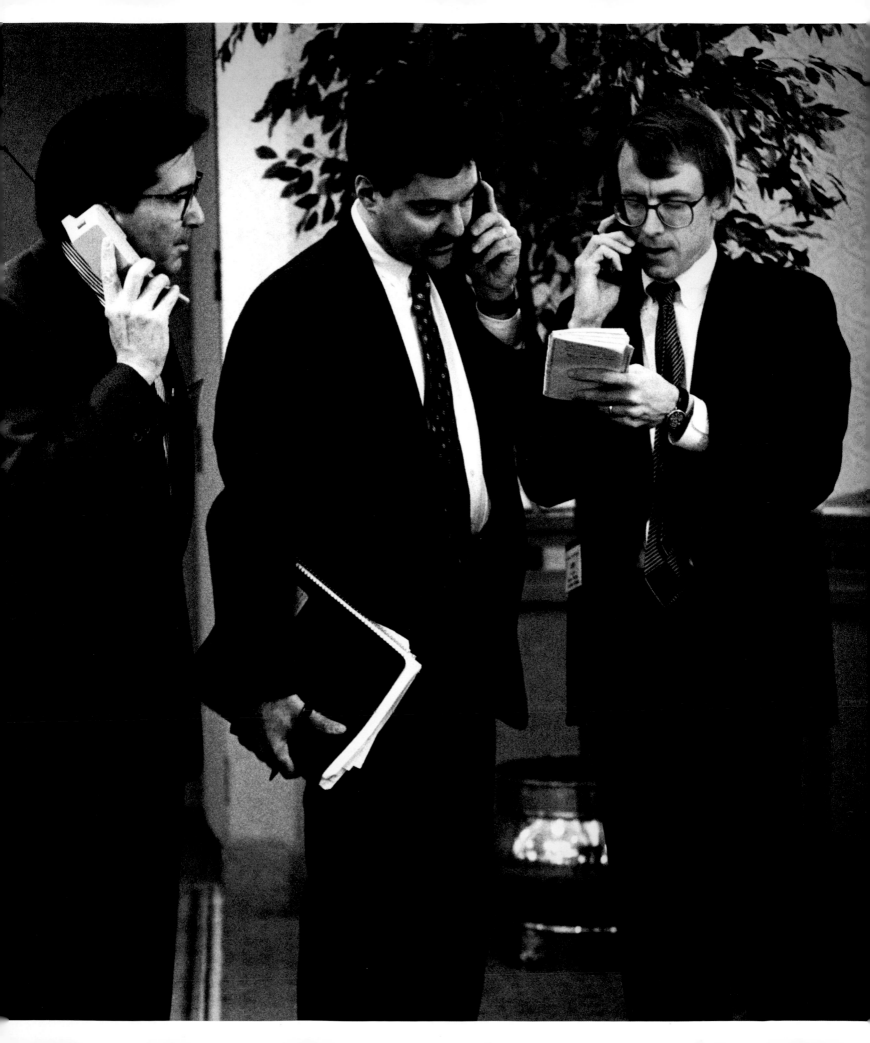

The Power Table.
Palo Alto, California, 1995.

A Kleiner Perkins dinner honored "name" partner Brook Byers (*center*), with a lot of good-natured roasting. Along with his colleagues in the room, he was (and remains) one of the most successful venture capitalists in Silicon Valley. Brook led the company's investments in biotech, health care, and medical technology. The venerable public relations innovator Regis McKenna (*left*) mentored the young Steve Jobs as he was starting Apple, introducing him to McKenna's extremely polished PR practices.

Investors.

San Francisco, California, 1991.

At a tech conference in a San Francisco hotel, a bit north and a world away from the grungy engineer start-ups of Silicon Valley, venture capitalists are making deals. The digital revolution could not have happened without experienced investors taking tremendous risks on the ideas and talents of young entrepreneurs. In 1975, the total outside investment in Silicon Valley was only in the low millions. By the time of this photograph, it was approaching $10 billion and rising. By 2000, it peaked at a staggering $111 billion.

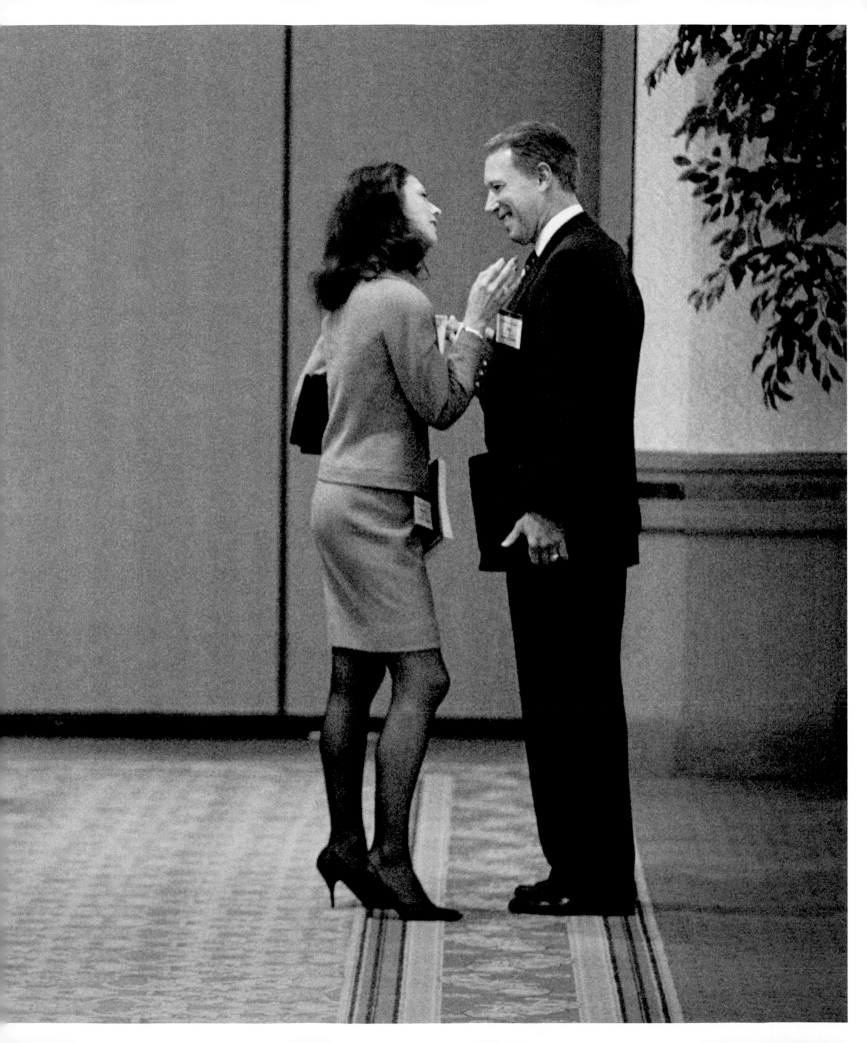

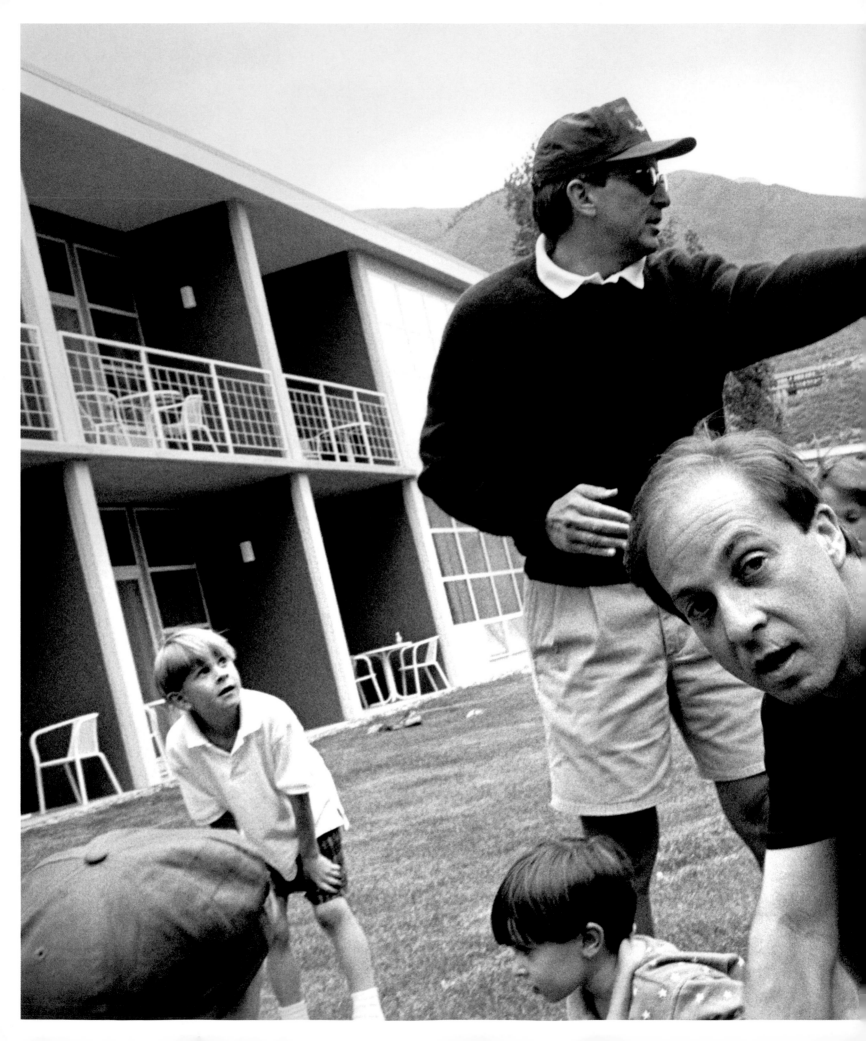

Calling the Play.
Aspen, Colorado, 1995.

Kleiner Perkins partners Brook Byers (*top*) and Joseph Lacob (*below*) play a game of touch football with the kids at their annual company gathering. Company partners, institutional investors, select entrepreneurs, and their families travel to Colorado for Kleiner Perkins's annual Aspen Summit to review the prior year, set strategy for the future, and relax in the surrounding Rockies.

The Young Mogul before the Merger.

Aspen, Colorado, 1995.

AOL CEO Steve Case checks his e-mail during a break at the Aspen Summit, five years before the ill-fated AOL/Time Warner merger. AOL was an internet pioneer, bringing millions online in the late 1980s with e-mail and other services, and Kleiner Perkins was an early believer and investor.

The Other Amazon.

Aspen, Colorado, 1995.

At the annual Kleiner Perkins Aspen Summit, my wife, Tereza, who is Brazilian, noticed a man wearing a T-shirt that said AMAZON. We went over to chat and assumed the conversation would be about Brazil and the famous river. Next thing we knew, we were riding up Aspen Mountain in the enclosed chairlift with a friendly Jeff Bezos. He explained that he was just starting this new company called Amazon.com. He practiced his fund-raising pitch on us and asked what we thought. What could we say? It was both astounding and disturbing. Local bookstores would suffer, yet it was so cool and practical it was clearly unstoppable. Unlike the rest of his former Wall Street colleagues, Jeff surprisingly embraced a risky long-term mind-set and was determined to gain market share before being profitable. He was proved right, but today Amazon still stands almost alone in this philosophy among US businesses.

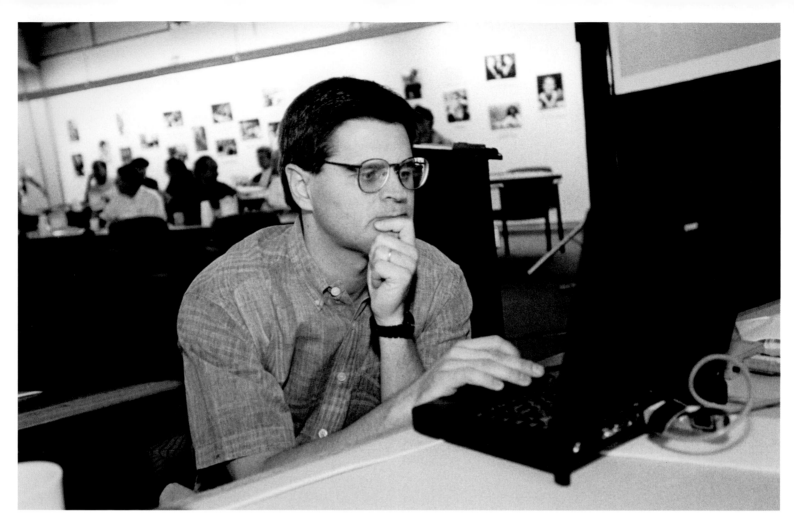
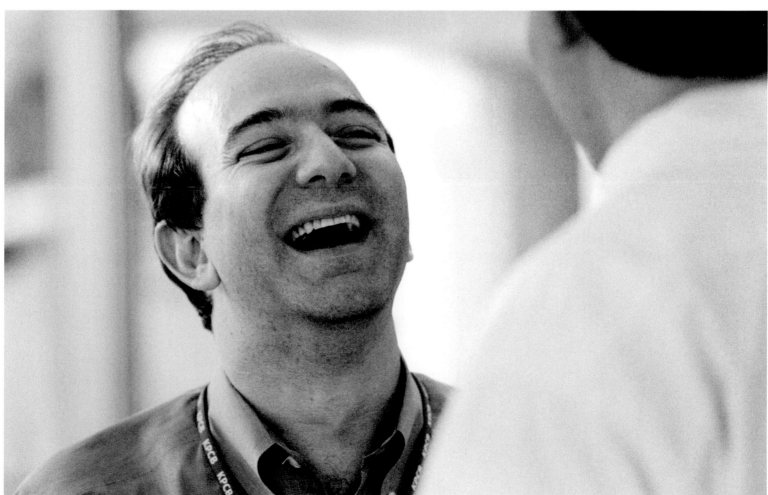

President Clinton Is Really Smart.

Mountain View, California, 1995.

During his reelection campaign, President
Bill Clinton attended a fund-raiser thrown by
the top CEOs of Silicon Valley. John Doerr
(*center*), interacting with Clinton, helped orga-
nize the visit at the home of Regis McKenna.
During dinner, the CEOs peppered Clinton
with questions related to complex technol-
ogy, trade, and economic issues. Listening
patiently, the president smoothly delivered
a point-by-point response to each guest in
turn, revealing a jaw-dropping breadth of
knowledge about all the issues, even obscure
aspects of encryption technology. Everyone
pulled out his checkbook and donated gener-
ously to the campaign.

Next Spread
High-Altitude Ambition.

Aspen, Colorado, 1993.

You could feel real excitement about the
massing potential of new technologies to
transform human life that came into focus in
conversations and presentations at the annual
Aspen Summit. Kleiner Perkins was hosting
some of the smartest entrepreneurs, scien-
tists, futurists, and financiers on the planet in
a buzzy, electric forum, sort of like a mini–TED
conference for the ultimate insiders. In this
relaxed and creative exchange of ideas, people
talked about the technology they were devel-
oping, hoping to develop, or needed to know
about to remain competitive.

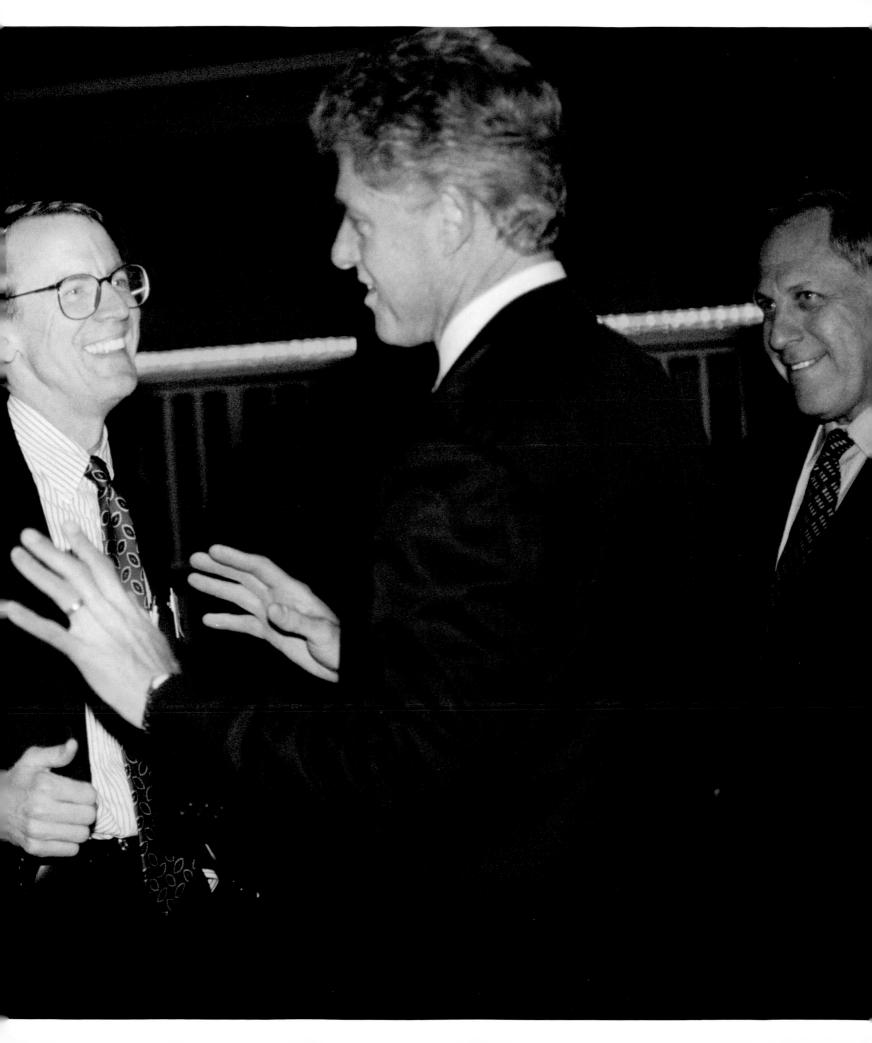

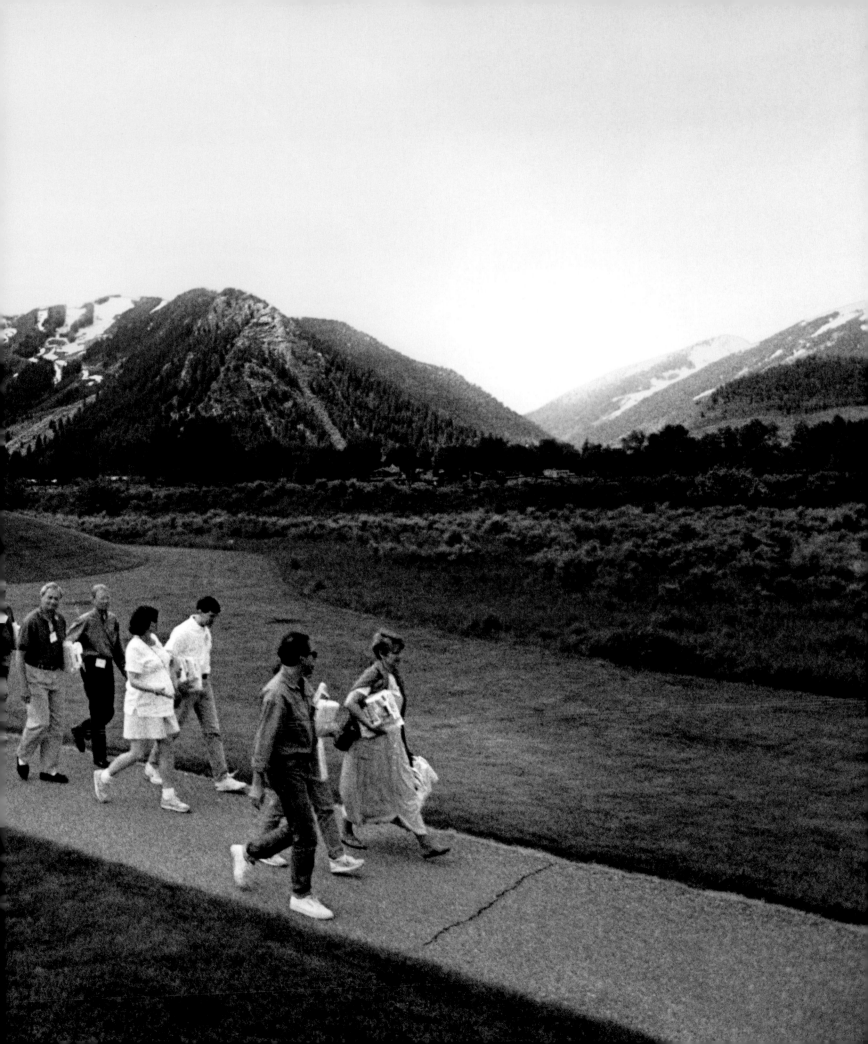

"Maybe the revolution is the point, not the profit."

—Bill Joy, cofounder, Sun Microsystems, on the importance of long-term, patient investments required to solve big technology challenges such as climate change

Bill Gates Says No One Should Ever Pay More Than $50 for a Photograph.

Laguna Niguel, California, 1992.

Microsoft CEO Bill Gates discusses cheap content for the masses and debates with reporters about the long-delayed vaporware upgrade to Windows at the Agenda '92 Conference, hosted by the elegantly acerbic Stuart Alsop. Alsop showed Gates no mercy during an interview onstage, grilling him on why Windows was so late. Later that year, at the third influential TED conference, Gates was onstage making a presentation about digital content and the cost of photography, saying, "No one should ever pay more than fifty bucks for a photograph." As Gates explained, he was completing construction of his high-tech house in Seattle, whose interiors would feature screens with continuously changing displays of images. Licensing images on the scale he envisioned would be expensive, so he began to think about how to own or control vast archives of images. This led to the idea of forming a stock photography business originally called Continuum, tasked with developing large image libraries for online distribution. Backstage at TED, Joan Rosenberg, a passionate defender of photographers and founder of the Center for Creative Imaging in Maine, was livid at Gate's comments. She lunged at him with a piercing cry. Steve Arnold, recruited from Lucasfilm to run Continuum, stepped in front of Bill and restrained Joan in the nick of time. Joan knew that Bill's pronouncement was the beginning of the end for the traditional ways photographers had always made a living. Indeed, Continuum's first contract was excoriated in the photography trade press for its aggressive rights grab, precipitating a name change. Thus, Corbis was born.

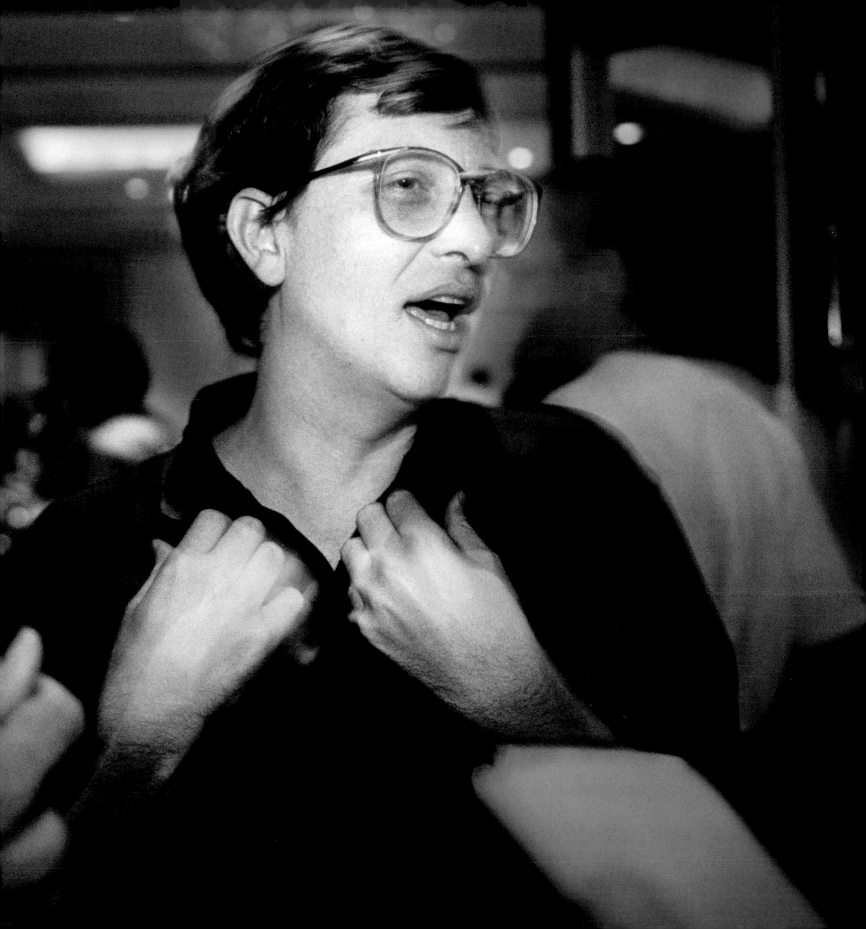

Getting with the Program.
Seattle, Washington, 1989.

Steve Ballmer, Microsoft's senior vice president of systems software (*right*), engages with a group of programmers at company headquarters in Redmond, Washington. In 1989, Ballmer was primarily working on OS/2, a new operating system being developed in partnership with IBM. A short time later, the partnership dissolved and Microsoft put all its focus on the Windows operating system, already generating huge profits. Ballmer is known for his explosive and quirky personality, and his tendency to shout. He could be wickedly funny, or downright terrifying, especially to Microsoft's competitors. He rose to become CEO in 2000 and recently announced he was stepping down.

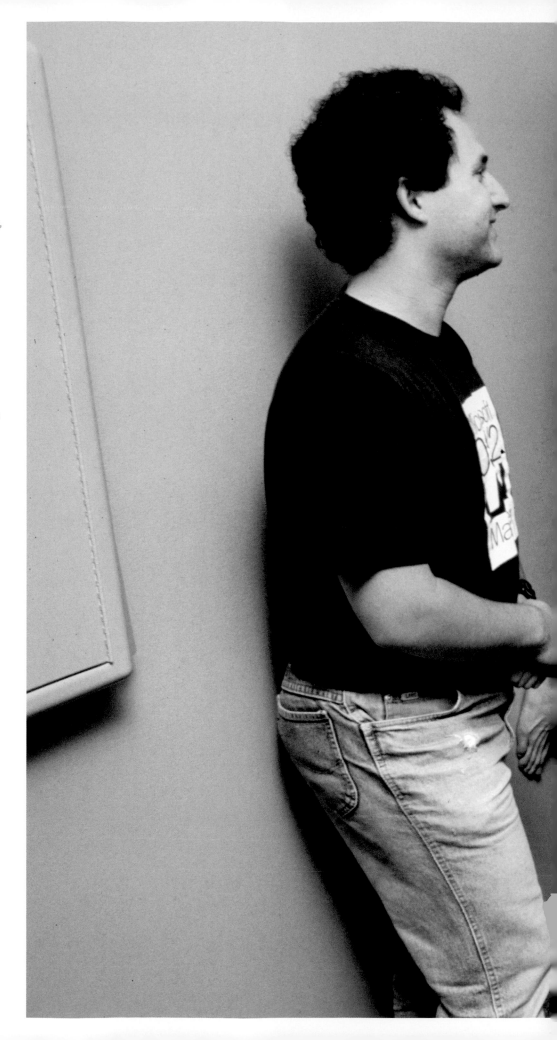

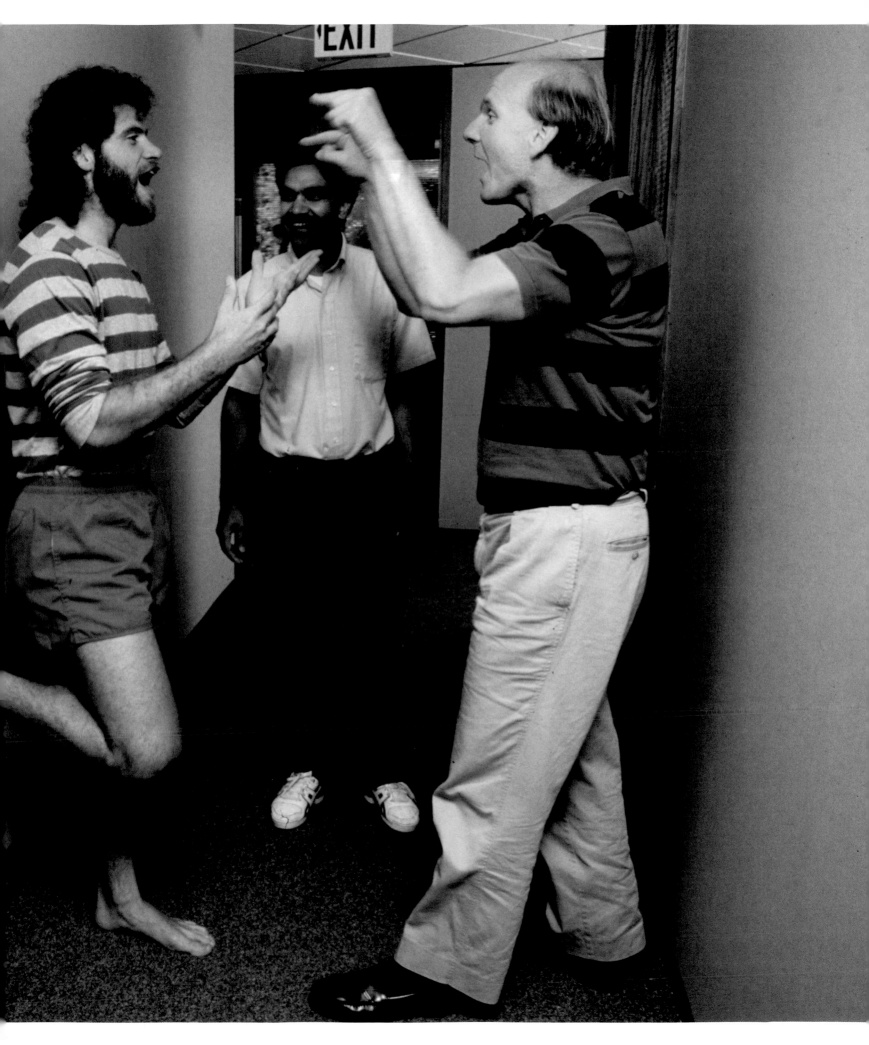

A Dog of Autodesk.

San Rafael, California, 1995.

Led by CEO Carol Bartz, Autodesk was one of the first tech companies to allow, even encourage, employees to bring pets to work. Studies now show interacting with pets lowers heart rates and stress at home and at work, but then the trend was a manifestation of the cultural shifts that a new generation of engineers had brought to Silicon Valley. Autodesk pioneered 3-D computer-aided design (CAD) software used by architects and engineers in everything from construction and manufacturing to media and entertainment. But Bartz and the company suffered through a tough period during the dot-com bubble. Said Bartz, "I'd go to investor conferences—with standing room only at presentations by Used-Fucking-Golfballs.com—and I'd get four shareholders listening to me." She persevered and by the early 2000s led the company to clearly dominate the computer-aided design software market.

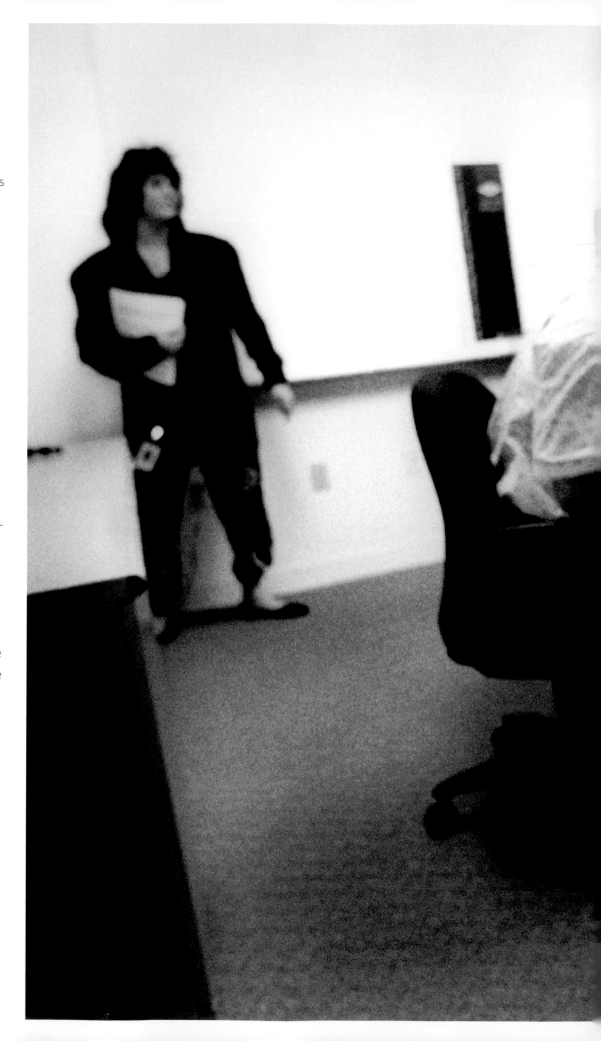

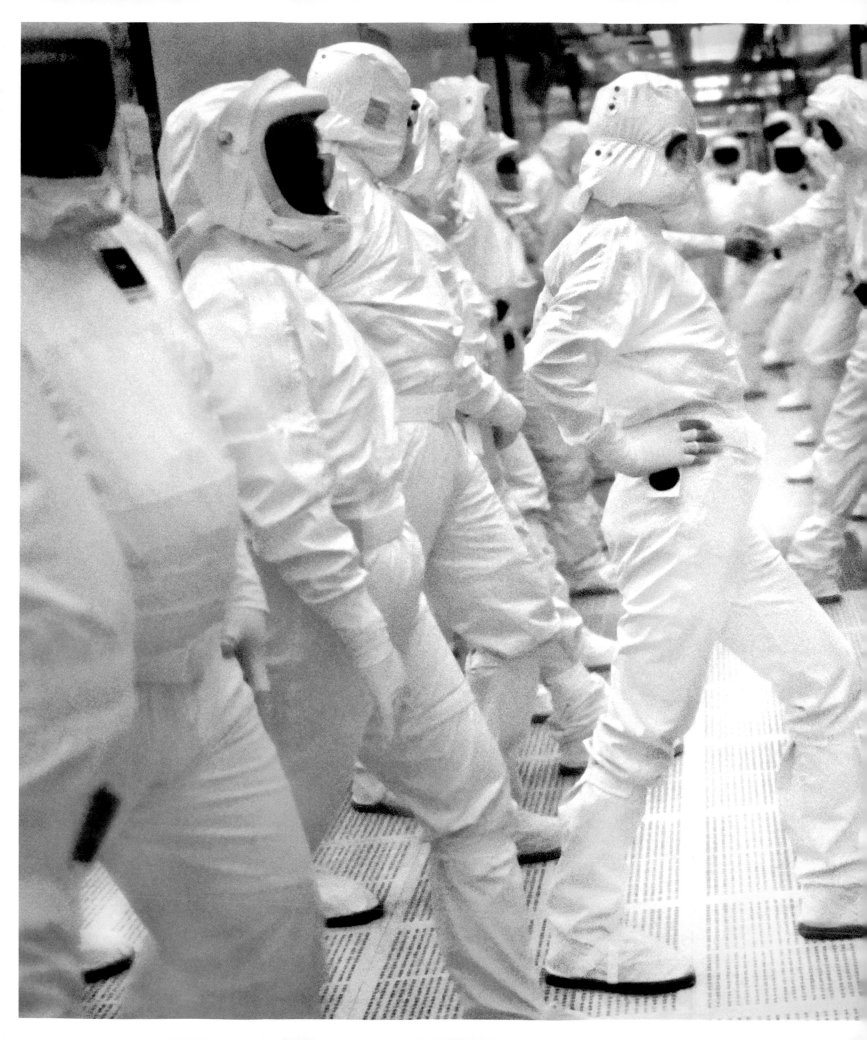

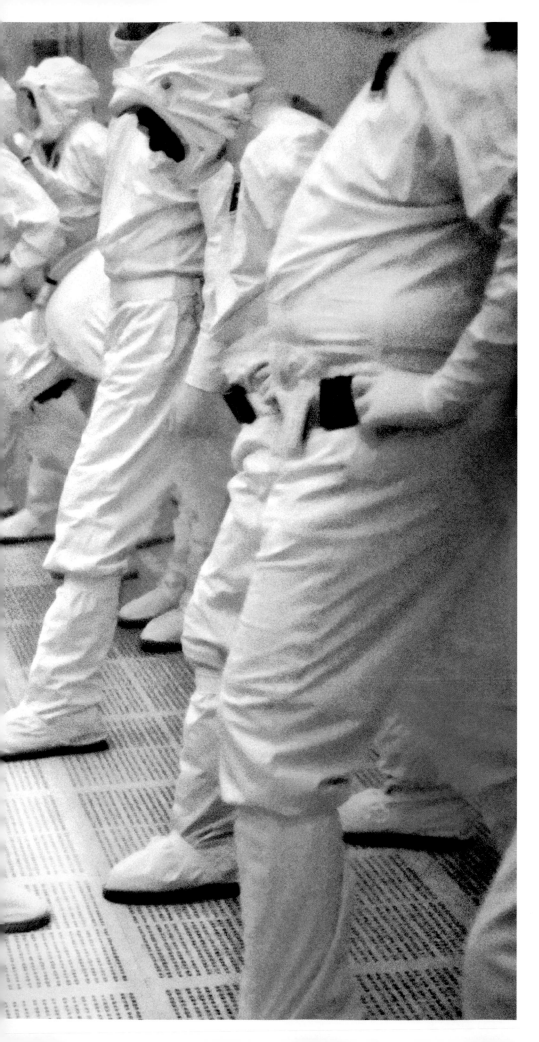

Exercise Break at Intel Fab 11X.
Rio Rancho, New Mexico, 1998.

Workers inside Intel's largest chip-fabrication plant exercise and stretch as part of their break time. The plant is a giant, sterile clean room, so protective "bunny suits" must be worn throughout the facility to prevent contamination from skin and hair. These workers produce five chips a second, twenty-four hours a day. Many of them are from the nearby Pueblo tribe and maintain their traditions when not working with new technology. After work, many tend their corn and bean fields with their families before dinner. An industry powerhouse, Intel helped Microsoft Windows become the dominant operating system, and today their chips run most of the PCs in the world. The company was founded by industry legends Gordon Moore and Robert Noyce; Andy Grove was their first employee. Moore famously posited Moore's law, and Noyce was the cocreator of the microchip that gave Silicon Valley its name and fueled its growth. Andy Grove become CEO and led Intel through a long period of tremendous growth. He became a mentor to Steve Jobs as Jobs began NeXT Computer. Although Jobs hated Microsoft Windows and was unhappy about Intel's support of Microsoft, he acknowledged the Pentium chip as "the coolest thing out there" when introduced. Shortly after he regained power at Apple, he switched Apple computers to Intel chips.

Previous Spread

Evidence of Human Activity.

Silicon Valley, California.

In the maelstrom of Silicon Valley it was relatively rare to find a superneat work space. Typically, elaborate personal decorations appeared with stacks of documents, electronic components, or parts of prototype machines being developed. The mess reflected the pace of the work. *Clockwise from top left:* a secret prototype of a tablet-size Newton, foreshadowing the iPad, at Apple Computer, Cupertino, California, 1993; tchotchkes and family photos define personal territory around a desk at Sun Microsystems, Mountain View, California, 1992; an engineering workbench in the Apple factory in Singapore, 1994; Newton prototypes on a desk at Apple Computer, Cupertino, California, 1992.

Difference of Opinion.

San Mateo, California, 1990.

During a break in a tense investment meeting, a manager aggressively makes his point during an "off-line" private dispute. Astonishing amounts of money were flowing into Silicon Valley, from retirement and pension funds, into investment funds like this one, stoking tempers and impairing judgment. Despite all the advances of the women's movement, Silicon Valley was an overtly male-dominated environment. In those days, women had to fight tooth and nail for everything—and more often than not still do. While an increasing number of highly visible women have been taking leadership roles, at the engineering level things are much the same.

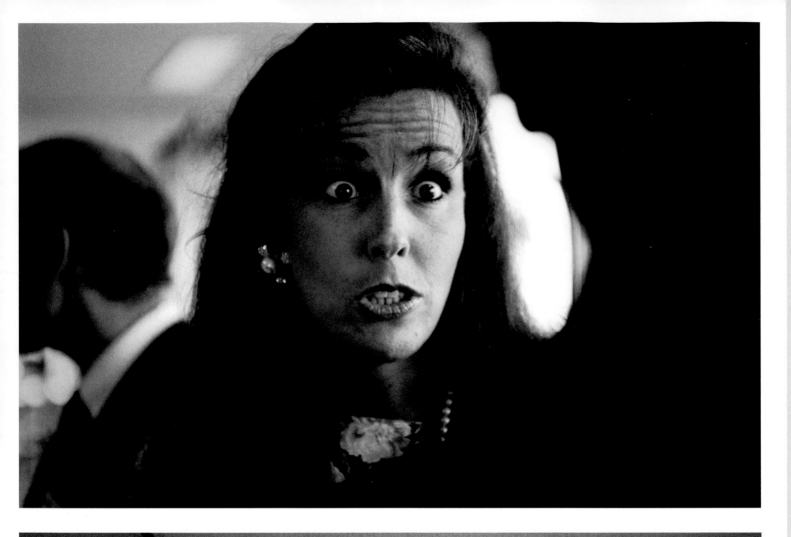
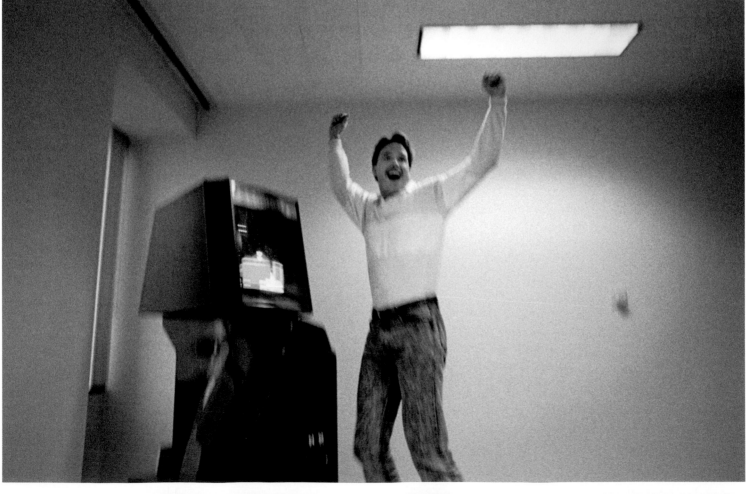

Anxiety Is Sweeping the Room.

Emeryville, California, 1991.

During a party at Farallon Computing to celebrate the company's expansion and move, employees discuss an upcoming deadline for a product demonstration at an industry trade show. Over the fifteen years that I documented the Valley, the competitive pressure to get new products to market faster was unrelenting and kept increasing every year. But getting to market became almost secondary to the prerelease marketing, the positioning and branding of upcoming new products. Resources were shifting from building products to building demos for more and more trade shows. The trade shows themselves became enormously profitable new enterprises built around the marketing of new technology.

Winning Isn't Everything, It's the Only Thing.

Berkeley, California, 1989.

An employee at Farallon Computing ascending to the highest level. Founded by Reese Jones, a biophysicist, inventor, and investor, Farallon Computing brought out a low-cost Macintosh networking system via PhoneNet, which implemented AppleTalk over telephone lines. Jones has multiple telecommunications patents and is working on a personal project: long-range evolutionary forecasts for life-forms on planet Earth.

129

Unknown Unknowns.
Fremont, California, 1990.

An engineer at Lam Research labors to solve an electrical connection problem in the assembly of a sophisticated plasma etching tool. The machine is used in the production of silicon integrated circuits.

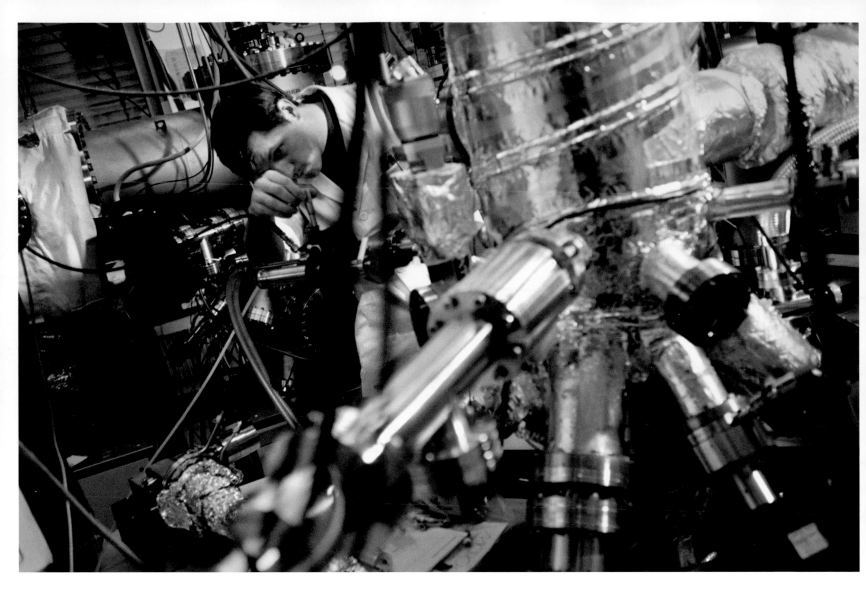

Soul of the Newest Machine.

Zurich, Switzerland, 1997.

Nanotech scientist Jean Fompeyrine of IBM's Advanced Functional Materials Group making adjustments to the molecular beam epitaxy system with which atomically precise thin films of different materials can be grown.

Time for the Future.

Zurich, Switzerland, 1997.

A traditional Swiss clock chimes out the passing hours in a lab at IBM's Advanced Functional Materials Group.

Right Place, Right Time, Right Skills.

Mountain View, California, 1996.

Marc Andreessen, doing a phone interview with the support of his publicist (*seated at right*), was exhausted and riding a monstrous wave of digital global change he helped precipitate. The press had been pleading for interviews with him ever since the Netscape Navigator browser was released, making internet access easy and fast for the masses. Andreessen cofounded Netscape with computer-graphics pioneer Jim Clark in 1994 with funding from Clark and from John Doerr of Kleiner Perkins. Andreessen was recruited by Clark after Andreessen cocreated the Mosaic browser while still a student at the University of Illinois. Their Netscape browser was an immediate hit and quickly gained 90 percent market share through 1995 and into 1996. They had lots of revenue from rapid growth, but had yet to realize profits when they offered their IPO in August 1995. In a milestone in Silicon Valley history, the IPO set records for first-day gains, improbably valuing their unprofitable dot-com at $2.9 billion. In 1996, Andreessen was photographed for the cover of *Time* magazine, barefoot and on a throne. The Netscape IPO flipped the conservative thinking about investing and incited the craze for dot-coms—even those without finished products, or profits. But Microsoft had already turned its Mordor-like gaze southward to Netscape, releasing its Internet Explorer browser for free and bundling it into its Windows '95 operating system. By early 1997, Goliath had crushed David, clearly winning the browser war. Netscape kept at it, laying off employees in 1998 to cut costs. But its market share was falling as fast as it had risen, from dominance down to 1 percent in a few short years.

Engineers at Beckman Instruments.
Fullerton, California, 1989.

Veteran engineers at Hewlett-Packard's then biggest rival, Beckman Instruments, with their pocket protectors and slide rules, present a classic image of nerds. They represent the mathematic pioneers and heroes of World War II, the space-race technology, and a generation of giants who built Silicon Valley. The Steve Jobs generation of hippie-geeks that followed brought a relaxed, rebellious attitude along with new ideas to disrupt the status quo. They tossed the pocket protectors, ties, rules, and regulations, turning the naturally cautious engineering culture upside down. Today, the United States lacks enough trained engineers to fill the millions of engineering jobs sitting open in its technology industry. In 2012, about three million jobs in the fields of science, technology, engineering, and math were unfilled since February 2011, according to the US Department of Labor. The problem persists today with lots of discussion but no easy solutions. The United States graduated fewer doctorates of computer science in 2012 than in 1970. When it comes to graduating computer science students at all levels, we just can't compete with countries such as China, Russia, and India. During the Bush administration, changes to visa rules further reduced the pool of talent in the United States by requiring all foreign engineering students to return home upon graduation.

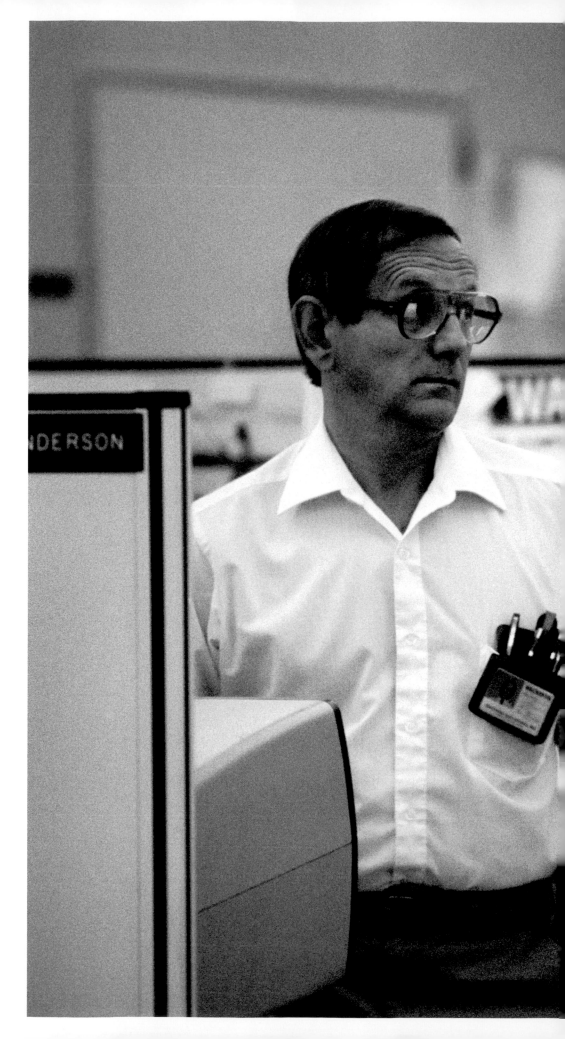

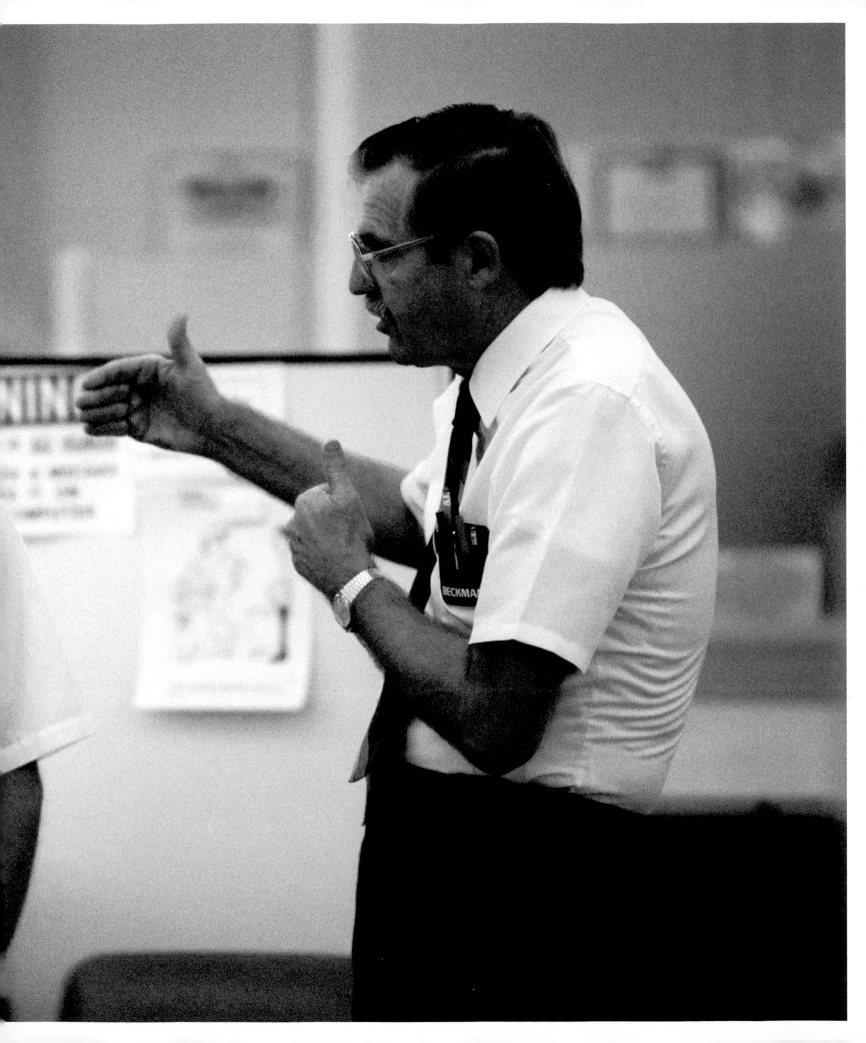

The Inconvenience of Success.
Santa Clara, California, 1992.

With its fast, low-cost workstations Sun Microsystems reached a billion dollars in revenue faster than any other tech company. The massive success came with increasing competitive pressure, and the company grew to over fifteen thousand employees worldwide in a few short years, forcing whole divisions to quickly move to bigger offices.

Next Spread
Turning the Ship Around.
IBM facilities in New York State, 1997.

Clockwise from top left: The hands of an IBM research scientist studying virtual reality appear on a monitor, Armonk, New York, 1997; IBM scientist Daniel C. Edelstein with a colleague examining their prototype copper chip that was so advanced it would shock the industry. With interconnectors made of copper—a better conductor than aluminum, the previous industry standard—the new chip ensured the continued advance of microprocessor speed for years to come, East Fishkill, New York, 1997; an IBM researcher prepares a presentation, East Fishkill, New York, 1997; IBM CEO Louis Gerstner talking about the radical restructuring of IBM then underway, Armonk, New York, 1997.

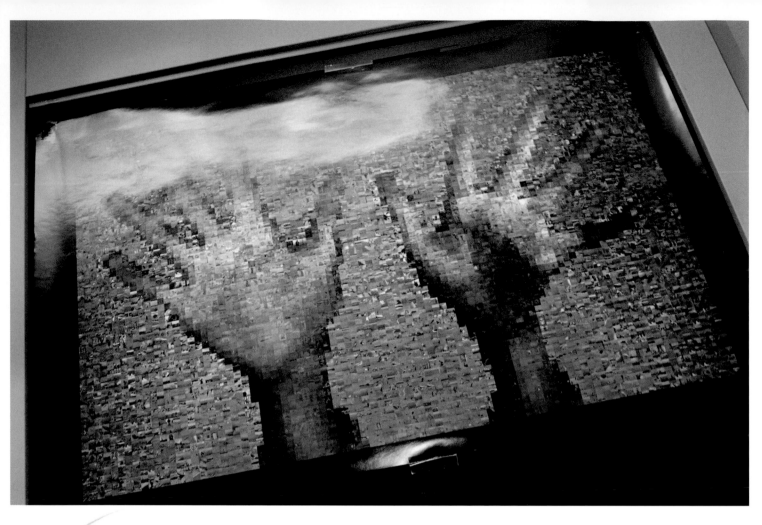

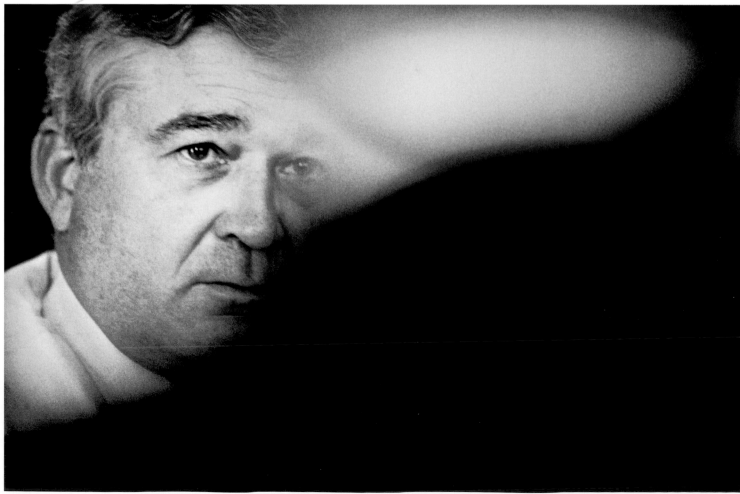

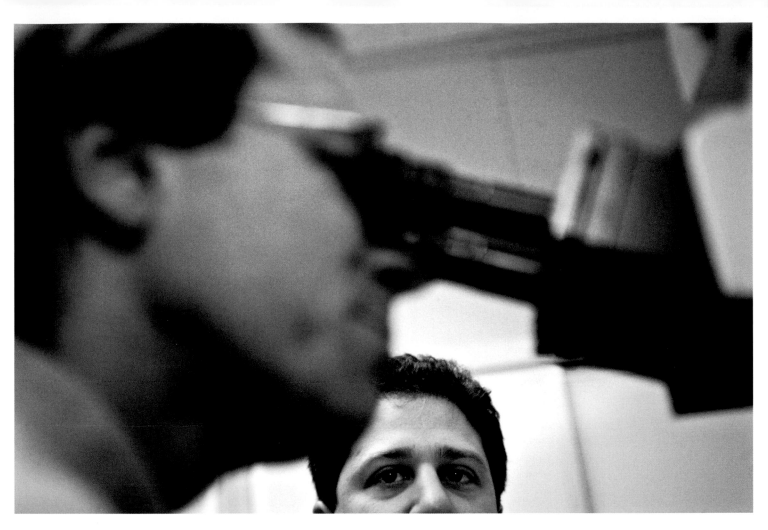

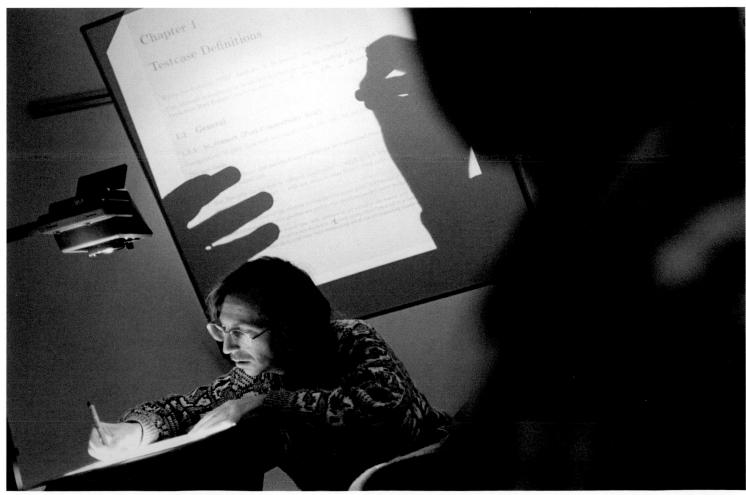

Bill Joy Is Worried about the Future of the Human Race.

Aspen, Colorado, 1998.

Legendary programmer and cofounder of
Sun Microsystems Bill Joy wrote Berkeley
Unix while a student at UC Berkeley and
helped the US Defense Department with
the TCP/IP stack code that allowed e-mail
to travel along the path of least resistance in
case of nuclear attack. He then cofounded
Sun Microsystems, became a billionaire, hus-
band, and father, and patron of the arts. He
also championed and helped finish the code
for Java, perhaps Sun Microsystems' most
important legacy. Bill now believes unfettered
innovation for its own sake endangers the
very existence of the human race. In 2000,
Bill published a manifesto in *Wired* magazine
that stunned the technology world by chal-
lenging the accepted wisdom of unrestrained
development. Triggered in part by meeting
noted scientist Ray Kurzweil and hearing his
ideas about the Singularity, when computers
gain consciousness and we will upload our
brains into a hive mind, Bill began forming
his thesis. He warned that without thought-
ful controls the convergence of our most
powerful twenty-first-century technologies—
robotics, supercomputers, nanotechnology,
and genetic engineering—might destroy the
human race. For the last decade, Bill has been
on a global hunt for scalable green technol-
ogy solutions to climate change. He says he's
identified ten "Edisons" capable of significant
breakthroughs if given proper funding. Unfor-
tunately, he is finding it harder and harder to
find investors willing to risk supporting these
kinds of extremely challenging, long-term
projects.

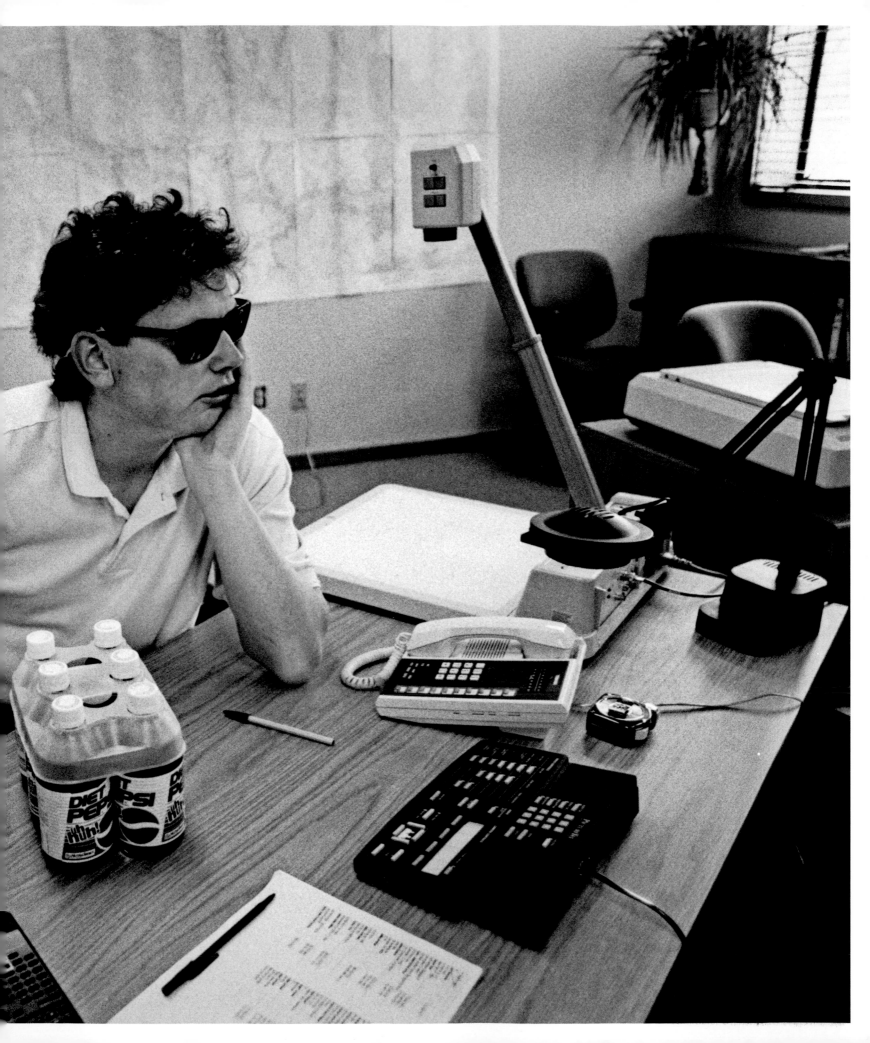

Manneken Pis Waters the Battle-ground at Sun Microsystems.
Santa Clara, California, 1995.

On the roof of Sun Microsystems, the Jolly Roger waves and a copy of the impudent Belgian _Manneken Pis_ statue endlessly urinates, while down below over a thousand employees are having an elaborate water fight. Staged across the corporate campus, it was led by their CEO, Scott McNealy, and senior management well equipped with water weapons. With its Unix-powered workstation, Sun was the fastest-growing technology company between 1985 and 1989.

A Plan for Global Golf.

Mountain View, California, 1991.

This is not a strategic business chart in Sun Microsystems CEO Scott McNealy's office, but an elaborate map of the golf courses he intended to play around the world.

United in Victory.

Santa Clara, California, 1992.

After a sloppy, hard-fought water battle between Sun employees from Sun Microsystems Laboratories and opposing forces from their SunSoft division, a seven-point treaty was negotiated and a draw declared. They went home soaking wet but as winners.

"The best part of the story is, by noon Monday I had ten million dollars in the bank."

—**Samir Arora**, cofounder and CEO of internet start-up NetObjects, relating his comeback from the brink of failure due to his investors' cutting off his company's funding.

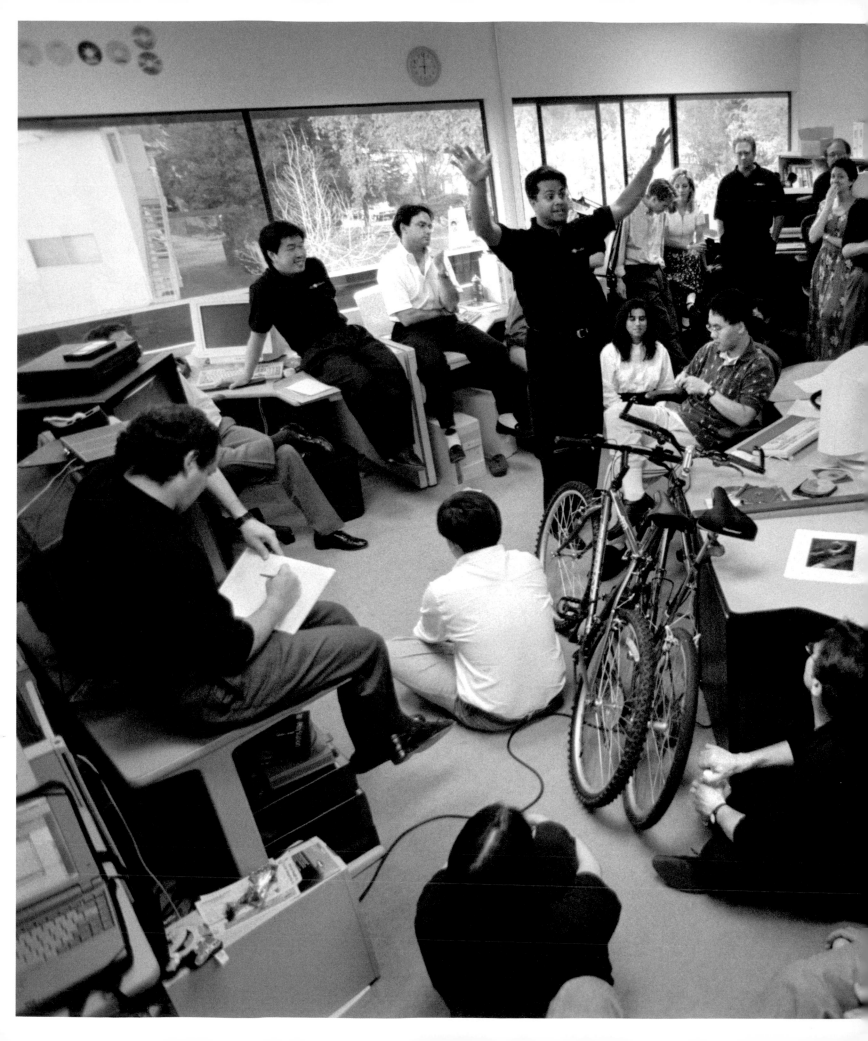

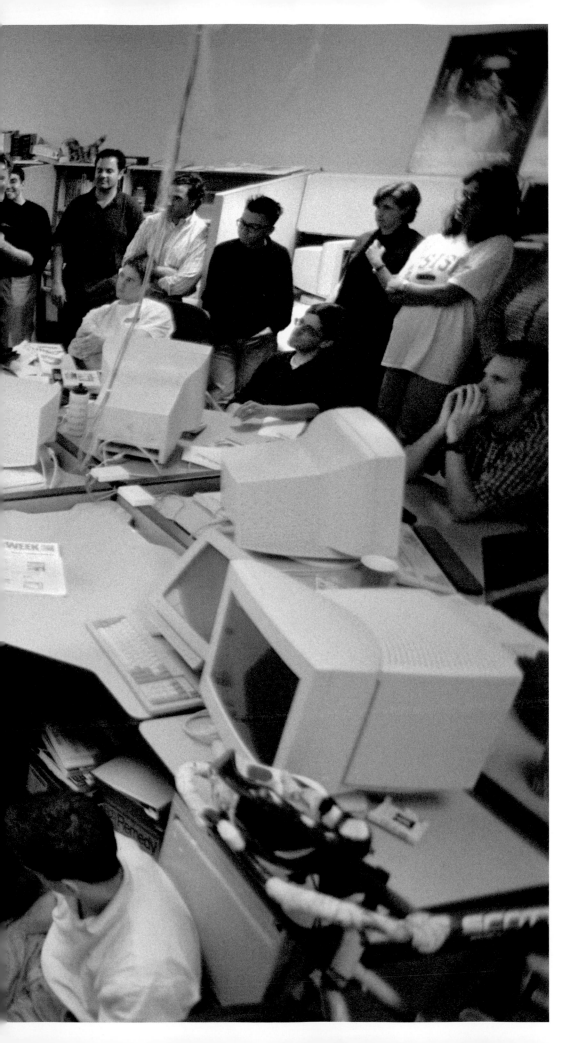

The Mission.

Redwood City, California, 1998.

NetObjects CEO and cofounder Samir Arora, who today heads mega-successful Glam Media, delivers a personal and moving talk to motivate his employees prior to a crucial board meeting with his investors. An inspirational leader, Arora was himself inspired by Steve Jobs and came from India to work at Apple as an engineer in 1986. He wrote a white paper with profound insights into the future of computing and rose quickly to work directly for Apple CEO John Sculley, where he helped develop Knowledge Navigator. He left Apple and with influential graphic designer Clement Mok (*seated, top left*), David Kleinberg (*seated, lower left, profile to camera*), and Arora's brother Sal Arora (*not pictured*), he cofounded NetObjects, which became the first company to create software that allowed anyone to make his or her own web pages. In short order they were a hot start-up with a mission to make the internet widely accessible, a smart product idea, decent funding, relatively cheap offices complete with foosball and Ping-Pong tables, and a brilliant, deeply dedicated group working long hours for low pay, with the hope of a big payoff someday for their shares in the company. They also believed in their product completely, unlike the employees of a lot of dot-coms of the era. But the pressure from competition such as Microsoft's FrontPage, and from their investors to do an IPO, was increasing. Arora's message to his employees that day: they just had to work even harder than they already were.

**Remains of an All-Night
Programming Session.**
Redwood City, California, 1997.

At the headquarters of NetObjects, morning finds empty Chinese-food cartons left by engineers working all night to finish an important updated version of the company's software. Other source material for programmers can include pizza, soda, and Ho Hos.

New Employees Are Requested to Wear Balloon Hats.
Redwood City, California, 1998.

Samir Arora (*at right in soft focus*) is pushing his team at NetObjects in their attempt to continue to dominate the market for web-page design software during a staff meeting at company headquarters. New employees were asked to wear balloon hats as a mild hazing ritual. This was believed to im- prove bonding of team members, so crucial in high-pressure work environments (or on battlefields).

A True Believer.

Redwood City, California, 1998.

Victor Zaud, NetObjects' director of product design, set up their six-person product design team with Clement Mok in 1996 and won awards for NetObjects' Fusion software interface design. Here he's talking with colleagues about his philosophy about NetObjects design as they update the software. He tries to evoke emotion in visual design and says that things can either be "horsey/clunky" or "tasty." He was particulaly taken with the icons that Susan Kare, former Apple designer and NeXT creative director, designed for the NetObjects navigation bar. Today Vic and Susan work with Samir Arora at Samir's new company, Glam Media. This movement of people from project to project is typical of Silicon Valley. It is home to a pool of extraordinarily talented people who come together to build a company, move on, bump into each other again, and start another cool company. Futurist and thought leader Paul Saffo says that this pinball-machine-like movement and proximity is one of the most significant factors that makes Silicon Valley unique as an engine of innovation.

Many Ways to Skin a Cat, Invent New Technology, or to Sit.

Redwood City, California, 1998.

Laura Zung, NetObjects' engineering director, was known at work for her unusual chair posture. Here she's discussing with a colleague the product launch schedule and marketing strategy for NetObjects Fusion's update. She often got up on a chair with her papers spread out on the floor, looking at everything while spinning slowly around in a circle. One of the critical engineering decisions NetObjects faced was whether to incorporate HTML, the universal programming language for assembling content into web pages, into their software or to remain a closed, proprietary system. They chose the latter.

159

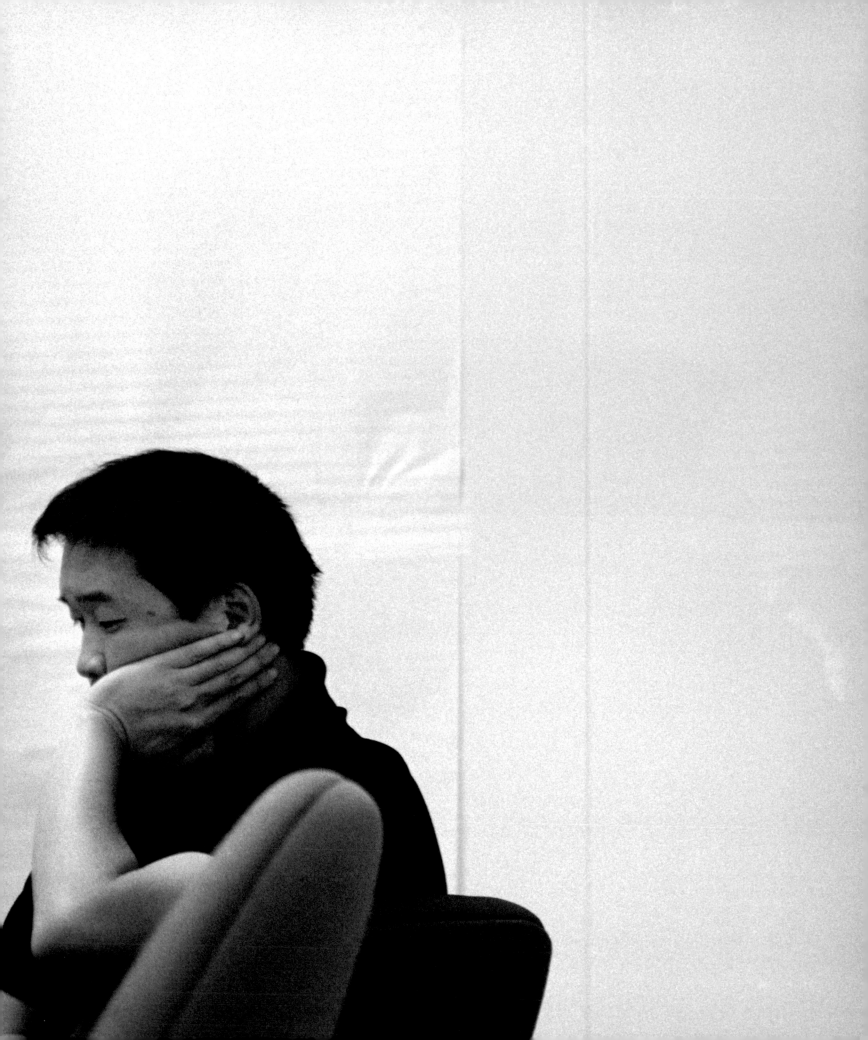

The Creative Process Never Stops.
Redwood City, California, 1996.

We can't get inside the head of the veteran graphic designer, author, entrepreneur, and visionary Clement Mok, but if we could, I imagine we'd see an endless flow of new ideas rushing by in giant 3-D, Technicolor imagery. Here he is seen lost in thought during a meeting at NetObjects, which he cofounded, about the company's Fusion software. Clement was Steve Jobs's creative director at Apple, helping to launch the Apple IIc and Macintosh.

Next Spread
Riding the Dot-Com Wave.
Redwood City, California, 1998.

At NetObjects (*clockwise from top left*) Greg Brown watches Moneka Hoogerbeets react to a demonstration of NetObjects software; cofounder Sal Arora working chairless; Steven Boye, senior director of engineering; an employee frozen midstride by conflicting demands.

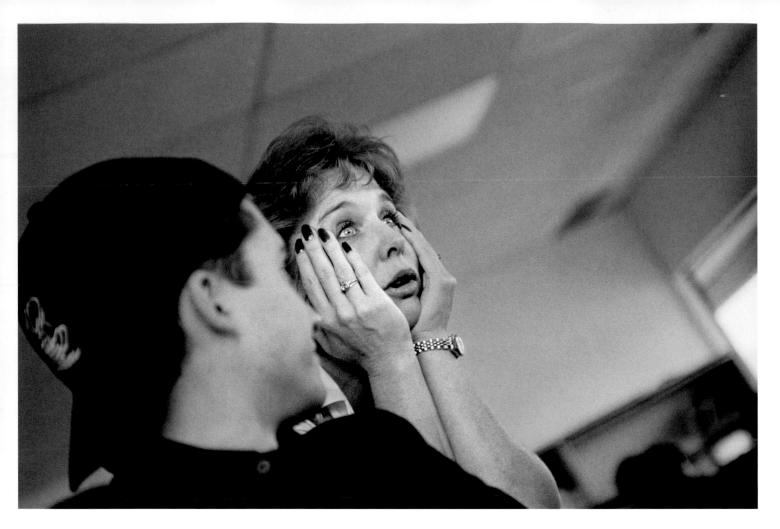
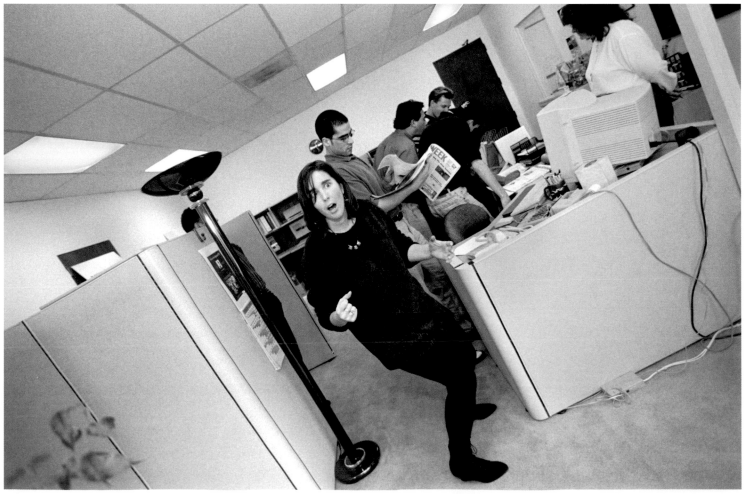

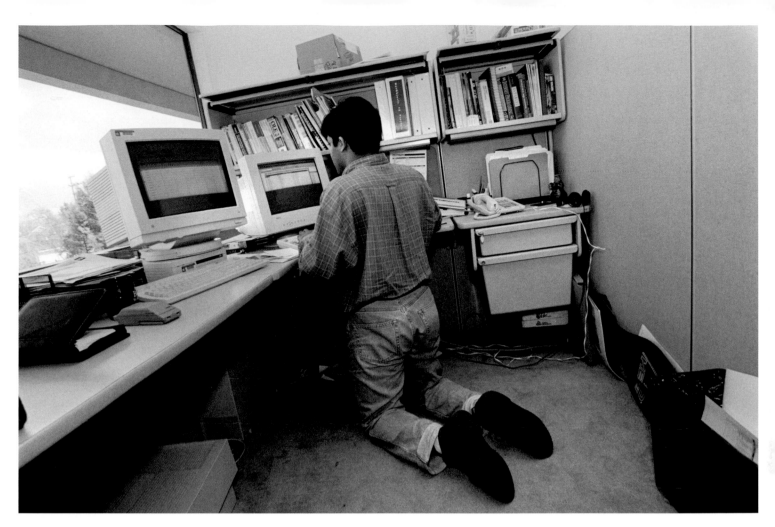

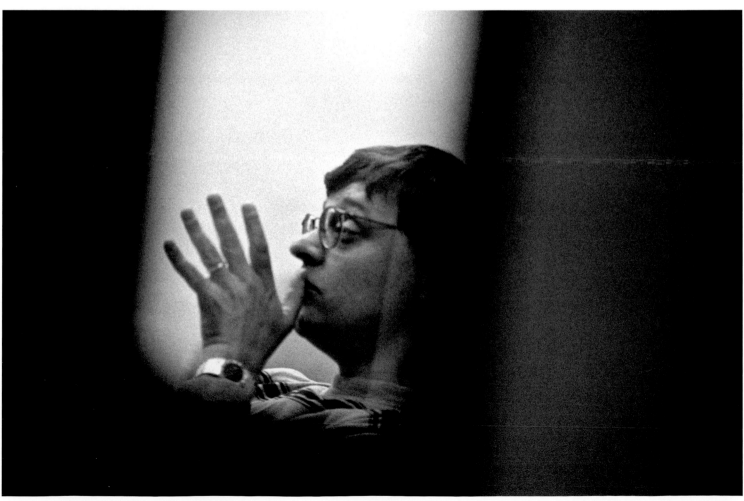

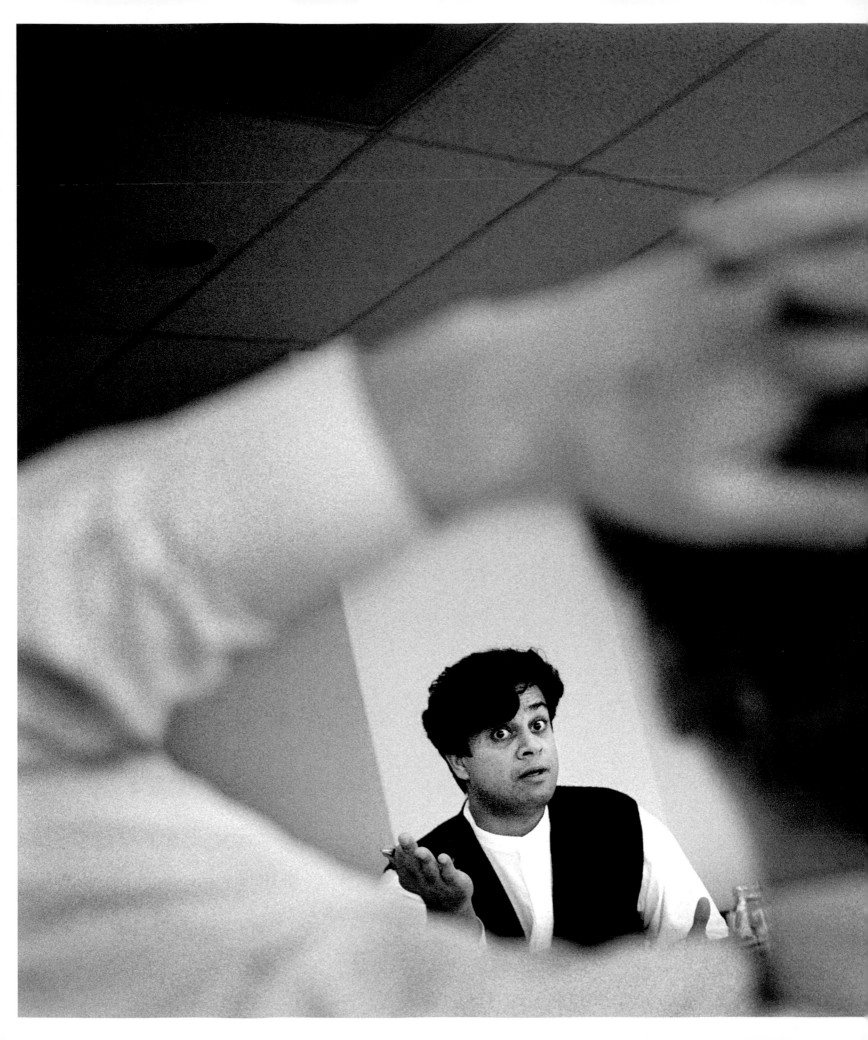

Samir Arora Facing Down His Investors.

Redwood City, California, 1999.

At 4:00 p.m. on a Friday, a contentious board meeting was getting even more so as the investors insisted that CEO and cofounder of NetObjects, Samir Arora, resign along with his president. The investors were unhappy with Samir's strategy in the face of increasing pressure from Microsoft and other issues. The entire roomful of board members cleared, leaving Samir alone in a shouting match with his two main backers. An enduring archetype of Silicon Valley has the innovator and founder pushed aside by the investors, sometimes for lack of management skills or conflicting strategic goals. Almost every company goes through this. Samir Arora broke the tradition, shockingly refusing to quit or to relinquish his vision, instead heatedly asking the investors to leave. They were furious and immediately cut off his funding, forcing Samir to stand an hour later before his 125 employees that Friday afternoon and announce that after four brutal years of blood, sweat, and tears they were in deep trouble. Samir declared he would not close the company and would find funding somehow. As Vic Zaud recalled, Samir asked those who believed in him and who could temporarily work without pay to stay on, and those who could not to leave. Vic stayed, as did most of the team. Samir began calling every investor he knew, and by noon Monday he had $10 million in the bank. Miraculous. NetObjects was saved. A short time later, he engineered a sale of the company to IBM, netting his investors a 1,000 percent return on investment. The astounding success was tempered later in March 1999 when NetObjects' initial public offering received a decidedly lukewarm response. Still, the IPO raised enough money, and NetObjects carried on a few more years until it was sold again. As employees quietly drank champagne, a TV played the news about the IPO. An anchor on CNN asked, "Is this the beginning of the end of the dot-com bubble?" It was.

End of the Dream.

Silicon Valley, 2000.

Whatever rises up must eventually falter and sink: that's the natural cycle of life. Knowing that things were bound to end was a constant worry and discussion point in Silicon Valley during my time there, but few noticed the exact moment when things began to unravel. The dot-com bubble collapse was such a slow-motion disaster at first, unfolding hesitantly through late 1999 into 2000, then accelerating with neck-snapping g-forces as it spread from local VCs, to Wall Street, to the big retirement funds and mom-and-pop investors. By 2001, trillions of dollars of shareholder value had washed away. It felt as though a toxic cloud had descended and hung over everyone and everything in the Bay Area, suffocating jobs and dreams. But soon Web 2.0 would boot up, with Google already growing fast and soon to be joined by Facebook, Twitter, and others to disrupt and burn new pathways, luring yet another generation to the Valley. While the hangover from the dot-com crash lingers, making investors shy of funding big-bet change-the-world ideas, an even newer batch of kids are poking their heads up and looking around for something perhaps more meaningful than short-term apps. A new wave of innovation is coming that could make the digital revolution pale by comparison. To catch that wave, innovators will no doubt have to be as passionate, hungry, and willing to sacrifice everything as those whose work is documented in these pages. Since the beginning, the pathfinders of Silicon Valley have always found that success was gained through fearless risk-taking and years of struggle. Failure often preceded success. Many also discovered meaning in their lives as they changed ours, through their quests to invent the impossible.

Acknowledgments

Since this project began twenty-eight years ago, so many people have helped me that it's impossible to acknowledge everyone who had an impact. I thank you profoundly and deeply regret any omissions.

Fearless Genius is a visual memoir and my personal interpretation of events I was allowed to witness. Many experts and friends in Silicon Valley patiently answered my questions but any errors, technical or otherwise, are mine alone.

I'd like to especially thank Steve Jobs for taking a chance and allowing me into his world with generosity and grace; to all those brilliant people in Silicon Valley and elsewhere who allowed me into their lives, my deepest gratitude; extreme awe and appreciation to my patient, funny, and diplomatic editor at Atria Books, Peter Borland, who gently but firmly brought cohesion to the whole, and to my elegant, risk-taking, and inspiring publisher, Judith Curr; and to designer Julian Peploe, who brought his exquisite eye, thoughtful discipline, and experience to create a superb presentation; to the rest of the hardworking team at Atria, including Daniel Loedel, Dana Sloan, Jim Thiel, Isolde Sauer, Jeanne Lee, Kimberly Goldstein, Kristen Lemire, David Brown, Hillary Tisman, Dan Cuddy, and Lisa Keim, it's been an honor to work with you all.

My everlasting thanks also to Rick Smolan and Jennifer Erwitt for long years of friendship, timely advice and also to Rick for suggesting I call Susan Kare in the first place; to Susan Kare for cheerfully opening the door to my future, along with her colleague and stalwart cofounder at NeXT, Dan'l Lewin, whose advocacy was crucial and who advises me still; special appreciation to John and Diane Sculley, John Warnock and Chuck Geschke, Marva Warnock, Russell Brown, Bill and Shannon Joy, Susan Rockrise, Eddie Lee, John Ison, and Samir and Rebecca Arora for taking so much time to listen, advise, and support the project; to Peter Howe at *Life* for his instant belief in the concept and long assignment that started it all; to Elliott Erwitt for taking time to review my pictures and spark me way back in the nineties to continue the project; to Jefe Supreme Karen Mullarkey for her sharp eye, wise counsel, and encouragement, her judicious and careful editing of the images and actually counting the 250,000 negatives by hand; to Jonathan Breiter, Tricia Chan, and David Mauer who bring the bright, clear light of friendship and razor-sharp business acumen every day; to Ann and L. John Doerr for their enthusiasm and steady faith, especially to Ann for bringing my archive to the attention of Stanford University; to Mike Keller, Assunta Pisani, Andrew Herkovic, Roberto Trujillo, Henry Lowood, and Tim Lenoir, who together, with the crucial guidance of Bill Gladstone and Surj Soni, were instrumental in bringing my work into the permanent collection of Stanford University Libraries; to the entire staff of Stanford University Libraries, in

particular Glynn Edwards, Lauren Scott, Stuart Snydman, Bill O'Hanlon, and Leslie Berlin; to David Elliot Cohen for patiently kicking my ass in the right direction over the years; to dearest Elodie Mailliet and everyone at Getty Images for years of nurturing enthusiasm and strategic effort; to Brian Storm for his early conviction and hard work; to Tom Walker for channeling Sisyphus over decades of uphill thinking on this from the start; to Susan White for great gusts of much-needed enthusiasm at just the right moment; to David Friend, a champion when few were willing to listen; to Jay Miller for crucial legal and moral support when times were toughest; to Jean-Jacques Naudet and Shiva for fiercely advocating my work to the world; to Dave Mendez, who gave several years selflessly to the project; to David Whitman for many reasons, but mostly because he loves Basenjis; to Kristen Galliani and Chris Holmes for their powerful friendship and magic powers; to Suzie Katz for being a diamond-tough and selfless guide to all photographers; with profound thanks to Bill Hunt, Howard Greenberg, and Ariel Shanberg for simply taking the work seriously; to Susan and Dennis Stock for deep camaraderie, long debates, and important insights; to Devyani Kamdar and David House for their buoyant good cheer and much-needed guest room; to Jennifer Fearon for her tireless efforts; to Michelle McNally for her priceless picture editing; to Mary Virginia Swanson for dreaming this could be a book and for pursuing that end; to Paul Foster, his lovely family and partner without whose patient generosity we could never have produced the scans; to my business manager, Joseph McNulty, and Emily Chao, who keep us fed and housed; to National Geographic Imaging, who did the exquisite scans under the supervision of Jeff Whatley with Howard Hull; to Eric Luden, Christopher Bowers, and the team at Digital Silver Imaging, who figured out how to make magnificent digital gelatin silver prints from my old analog black-and-white negatives; to Josh Marianelli and Molly Peters, who labored mightily over the years in my studio, and to all the other studio managers, photo assistants, and interns who lent their talents; to my veteran agents, Bill Stockland and Maureen Martel, and the extraordinary team at Stockland Martel; to Anette Ayala for getting me from A to B effortlessly; and of course to my dear wife, Tereza, and my son, Paolo, who worked so hard while putting up with the obsession and travel, and to whom this work is dedicated; to all the Machados: sisters, brother, cousins; and to my sister, Stephanie, who sacrificed so much to help me; to my parents and entire family, who were there for me from beginning to end, my continued love and gratitude.

I'd also like to thank:

Thiana Anderson

Kirk Anspach

Ekaterina Arsenieva

Michael Ash

Mary K. Baumann

Steven Beer

Gene Blumberg

Amy Bonetti

Chris Boot

Clive Booth & Mari Morris

Ruby Boyke

Steve Broback

Dan Broder

Joe Brown

Charlotte Burgess-Auburn

Tom Byers

Maryann Camilleri

Marc Carlucci

Rupa Chatervedi

Joshua Cohen

Kate Contakos

Michael Costuros

Gilles Decamps

Jim Demarcantonio

Maria Diehl

Jeff Dunas

Kent Dunne

Marten Elder

Ellen Erwitt

Rai Favacho

Mariana Fedalto

Kristina Feliciano

Demetrius Fordham

Caitlin Frackelton

Keith Gemerek

Gillian George

Dr. Paul Gilbert

Martin Gisborne

Tamika Harold

Michael Hawley

Polly Hopkins

Simon Horobin

Holly Stuart Hughes

Ekaterina Inozemtseva

Geoff Jarrett

Quinton Jones

Reese Jones

Daisy Jopling

Jon Kamen

Michael Keller

David Hume Kennerly

Douglas & Francoise Kirkland

Harlan & Sandy Kleiman

Julia Korotkova

Markos Koumalakis

Bill Kouwenhoven

Emily Leonardo

Jean François Leroy

Susan Lewin

Ellodie Mailliet

John Markoff

Lesley A. Martin

C. J. Maupin

Dan McCabe

Michael McCabe

Michele McNally

Phoebe Mendez

Jesse Miller

Alice Monteil

Eugene Mopsik

Martin O'Connor

Silvia Omedes

Khadijat Oseni

Andy Patrick

Nora Paul

Bob Peacock

P. J. Pereira

Jason Preston

Serena Qu

Joe Regal

Sascha Renner

Roger Ricco

Tom Rielly

Cat Ring

Tim Ritchie

Jeff Roberts

Andrew Rockrise

Marcel & Jean Saba

Michelle Sack

Paul Saffo

Doug Scott

Karen Sipprell

Alicia Skalin

Phoebe & Jesse Smolan

Urs Stahel

Leonard Steinberg

Brent Stickels

Michael Strong

Jeff Summer

Olga Sviblova

Sina Tamaddon

Jay Tanen

Michael Tchao

Daniel Terna

Kathryn Tyrrel O'Connor

Kelsie Van Deman

Helena Velez Olabarria

David Walker

Thomas K. Walker

Ada Walton

Jill Waterman

Andy & Angela Watt

Debra Weiss

Jerrett Wells

Lauren Wendle

Olga Yakovleva

Duan Yuting

31901055498895